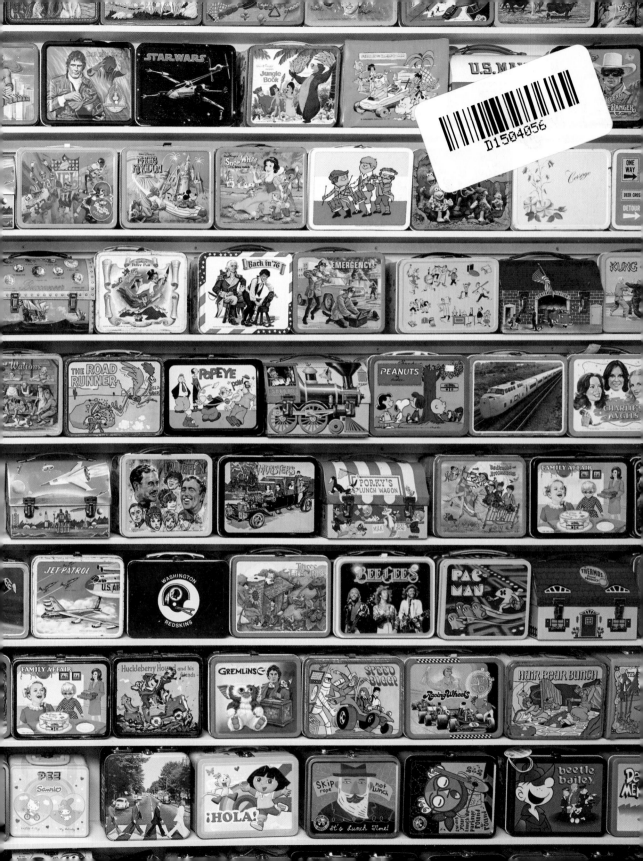

SCHOOL LUNCH

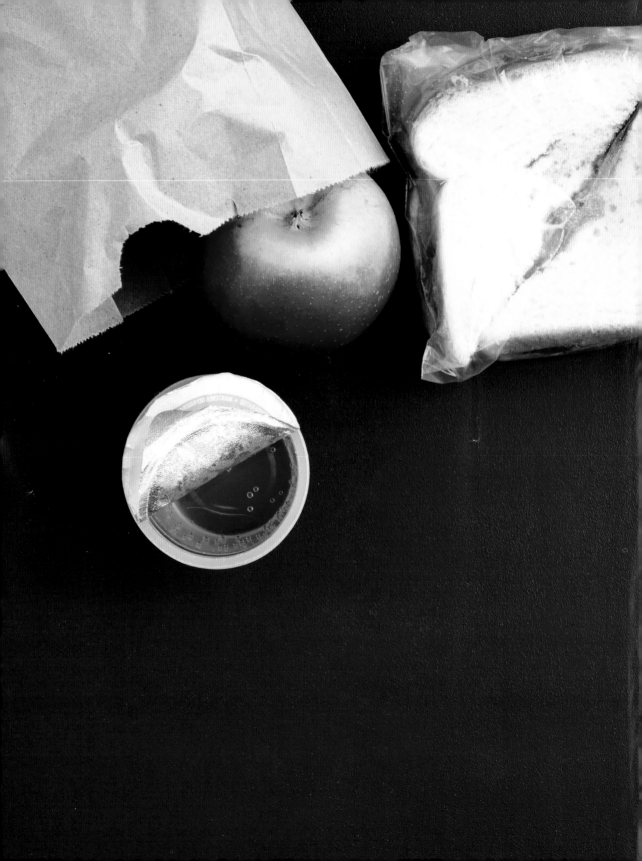

SCHOOL LUNCH

UNPACKING OUR SHARED STORIES

LUCY SCHAEFFER

Running Press
PHILADELPHIA

Running Press
Hachette Book Group
1290 Avenue of the Americas, New York, NY 10104
www.runningpress.com
@Running_Press

Printed in China

First Edition: June 2020

Published by Running Press, an imprint of Perseus Books, LLC, a subsidiary of
Hachette Book Group, Inc. The Running Press name and logo is a trademark
of the Hachette Book Group.

The Hachette Speakers Bureau provides a wide range of authors for speaking events.
To find out more, go to www.hachettespeakersbureau.com or call (866) 376-6591.

The publisher is not responsible for websites (or their content) that are not
owned by the publisher.

Print book cover and interior design by Amanda Richmond
Food Styling by Chris Barsch
Prop Styling by Martha Bernabe

Library of Congress Control Number: 2019956737

ISBNs: 978-0-7624-9445-3 (hardcover), 978-0-7624-9444-6 (ebook)

RRD-S

10 9 8 7 6 5 4 3 2 1

For Georgia and Annie,
my beautiful daughters who forgive me when
I accidentally switch their lunch bags.

CONTENTS

STORIES

Introduction

MY PARENTS ONCE JOKED ABOUT PACKING A DEAD MOUSE IN MY little brother's school lunch. The fall Mikey started first grade, the field mice were growing bold and trying to colonize the warmer nooks and crannies of our cupboards. Traps were snapping daily. Simultaneously, at school, my brother's entire bag lunch was being swiped from his backpack before lunch period. My parents reasoned a dead mouse sandwich might scare a young thief straight. Ultimately, a simpler solution prevailed. My mom—a wonderful cook and baker for my whole childhood—had been making homemade bread and cookies for Mikey's lunches, with him helping at her side. She decided to lower the bar. She swapped their homemade bread for store-bought and skipped the cookies. The lunch bag thievery halted immediately. Seems some little kid had just been unable to resist the temptation of her home cooking.

While I must have had some of that homemade bread myself, for the most part my own elementary school lunch was standard fare: peanut butter and jelly, corn chips (which I liked to stick in my sandwich for added crunch), carrot sticks, a box of Juicy Juice, and a packaged Little Debbie treat—all tucked neatly in my metal *Pigs in Space* lunch box. While this seemed absolutely average and unremarkable at the time, I can look back on it now as having an indelible time and culture stamp, one that every school lunch bears.

I've come to realize that school lunch is the perfect lens through which to consider what it means to be American. When I first started this project, I had no idea the depth and breadth of experiences I would discover. I've collected stories from people aged six to ninety-three; hailing from twenty-five different countries and all across the United States. My subjects include celebrities, homeless people, strangers, my parents, our corner bodega owner, and my Korean father-in-law. Each story highlights our diversity while revealing our common experiences and our shared humanity. No matter where everyone came from or how divergent their childhood circumstances were, we are all Americans now. Our diversity is our strength. Now more than ever, this feels important to me to celebrate.

The lunches in this book are focused on the elementary school years. With all the mythology around the carefree innocence of childhood, it's easy to forget that at that age, you don't have much control. For lunch, you get what the adults around you decide you should eat or are able to provide—whether you like it or not. Micaela Walker recalls getting the *exact* same lunch every day for six years. She begged her mother to change just the direction she cut the sandwich, but with no luck. Many kids remember cafeteria trays with overcooked, ignored veggies and mystery meat. That's life as a kid.

Of course, not all family circumstances are equal. George Foreman remembers blowing up an empty paper bag and bringing it to school on the days when there wasn't food at home. Many countries seem to do a better job than ours at providing healthy, free school meal options for kids. Hearing some of those international cafeteria stories was eye opening. I'd happily eat Marcus Samuelsson's Swedish school lunch of pancakes with fried ham and lingonberry jam every day for six years.

It's remarkable how vividly adults remember visceral details of their child-hood lunches, and how those lunches made them feel. Annegrete Barnum, who was eighty-eight when we spoke, recalled her childhood school lunches during World War II and in Allied-occupied Germany. She eagerly described brown bread, spread with lard and sprinkled with sugar, as clearly as if she had just eaten it that morning.

Padma Lakshmi recalled the shame of being different when she took out her pungent Indian lunch in front of American classmates. She still remem-bers feeling conflicted. The taunts stung, but she preferred her lunch to their bland white-bread sandwiches and thus didn't actually want to trade. Diep Tran, transported to a Los Angeles suburb from Vietnam as a refugee, remembers being delighted and fascinated when she first encountered fan-ciful American dishes such as "corn dogs," a dish whose name reveals little about its contents.

People recalled with equal clarity items they *didn't* get in their lunches. Items that other, luckier kids lorded over them. Deals, trades, and pleas for those coveted commodities seem to be a universal experience that crosses cultural boundaries. Benevolent classmates who shared such luxuries are

remembered fondly by first and last names decades later. I've asked hundreds of people about their school lunches and can conclude most of us remember *other* kids as being the ones who got the really "good stuff."

Familial idiosyncrasies play just as large a role as culture in determining school lunch. One mom, dad, or grandparent can sway what is expected, by doing things their own way.

Aya Ogawa's Japanese mother brought personal ingenuity to the lunches she packed. The family had lived in Atlanta, Georgia, for a few years before Aya started kindergarten in Tokyo—long enough for her to acquire a strong taste for American baloney. Back in Tokyo, Aya's mother synthesized the two cultures and tastes. She packed baloney sandwiches on white bread with crusts trimmed and then cut into six rectangles, spelling the kanji characters of their family name, Ogawa (小\|\川).

A completely different maternal adaptation story comes from Josephine Mangual. Growing up in Spanish Harlem in the 1960s, she and her Puerto Rican friends chatted and laughed but ate nothing during lunch period in the cafeteria. Their real lunch came at recess, when their mothers gathered daily with tins of hot food that they passed through the playground fence. It was a social gathering for the women as much as sustenance for the children. They always brought extra for all the additional kids who flocked over hoping for a taste of fried plantains or *limbers*, homemade popsicles.

In the same city, thirty years later, Felicia Johnson's father would pack her two simple but identical brown bag lunches; one for her, and one to give to someone who didn't have one.

On the surface, these anecdotes seem to be about baloney, beans, and brown bags, but they're really about love notes from parents to their children—and sometimes even other people's children. They are values being passed down a generation. The lunches plopped on our trays as kids shape the adults we become.

I hope you will enjoy reading these stories just as much as I've enjoyed collecting them. Steven Engler, a subject of this book and owner of one of the largest collections of vintage lunch boxes in the nation noted, "If you stand in front of a wall of lunch boxes, you're going to charge up. They're all positive." The stories in *School Lunch* aren't all positive: they range from light-hearted

to nostalgic to serious, but overall the experience of connecting with people about their school lunches has charged me up. Viewed all together, the memories in this book are simultaneously mundane and brilliant, creative and practical, special and everyday—just like school lunch itself.

Author's Note

EACH LUNCH STORY IS WRITTEN IN FIRST-PERSON NARRATIVE TO HIGH-light the subjects' voices over my own. Most stories are distilled from lengthy, recorded phone or in-person interviews. In addition to asking questions soliciting general lunch memories, I asked each subject very detailed questions about the visual aspects of their lunches to be able to re-create food photographs to a tee (crusts on or off? What color lunchroom tray? How many layers in the tiffin box?). Each entry has been edited for sequence, clarity, and brevity but maintains as many direct, unmodified quotes as possible. To help contextualize the stories I've included a year and place with each subject. The year is the year they were born, and the place (with a few exceptions) is where they grew up and attended elementary school.

About a dozen stories included in this book come from a Portrait-Pop-Up booth I ran in New York City's Union Square. I spent a summer day offering free portraits in exchange for shared lunch stories and photographed over eighty individuals. At the booth, each person filled out a written questionnaire. The ones I chose to include in this book from the Pop-Up were interviewed again whenever possible.

STORIES

CLEVER WARTIME TRADING

JACQUES PEPIN

Internationally Recognized Chef, Television Personality, and Author
Bourg, France, 1935

———————

DURING THE WAR NO ONE HAD ANY MONEY AND LUNCH WAS TERRIBLE.
From ages five to seven, I went to a Jesuit school. They took me early because
my father had joined the Resistance and my mother couldn't take care of me.
They used to serve us a kind of bread, made from whatever flour they could
find. It was hard as a rock, dry, and full of bugs. The older boys taught me
to bang it on the table and wait for the bugs to come out before trying to
eat it. The priests also served a liquid porridge gruel that was inedible. They
were really tough and forced us all to eat it. We were starving but it was so
disgusting that kids would sometimes try to hide it in their pockets.

I came from the town but two-thirds of the kids came from local farms.
They were the lucky ones—they would come to school with a jar of duck fat, or
honey, or jam from their farms. Guys like me would try to barter to get a little
bit of it for our bread. I remember one time, I begged one kid for some salted
pork fat from his jar and he gave it to me. Then I got an idea. I turned the
bread over and asked another kid for some of his jam on the other side. I was
delighted when that worked. The taste didn't go together but I didn't care.

By the time I was eight, my mother had a restaurant in a small town a
mile from school. I would walk to school, walk back for lunch and then walk
back for more school. Lunch would be egg, salad, and stew with potatoes
and meat if she could get the meat. My father was still in the Resistance;
occasionally when he could, he would sneak things out and we'd have tuna
or mackerel.

By the time the war finished in 1945 I was ten years old. My mother had
another restaurant and there was better food. At age thirteen, I quit school
to apprentice full-time in a restaurant.

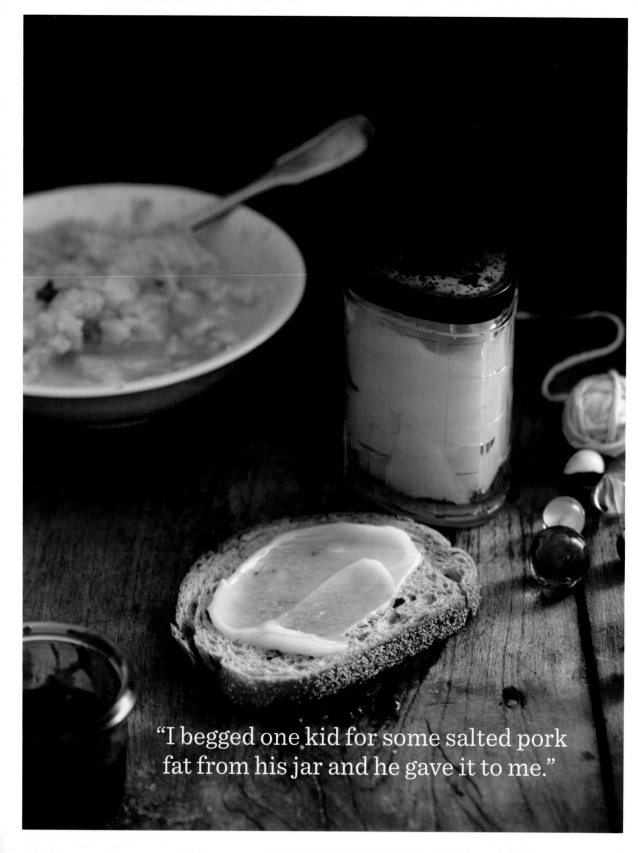

"I begged one kid for some salted pork fat from his jar and he gave it to me."

SIX YEARS WITH THE EXACT SAME LUNCH

MICAELA WALKER

Recent Masters Graduate in Library and Information Science
Manhattan, New York, 1976

I LOVE MY MOM BUT SHE'S A HORRIBLE COOK.

I ate the same damn thing every day for six years: peanut butter and jelly, an apple, and apple juice. My mom hated cooking and resented having to pack lunches. I don't know if it occurred to her to give me something different. She also had this thing about putting *butter* under the jelly which I thought was disgusting but she maintained you had to do it or the jelly would leak through. We'd have this constant battle. I really wanted my sandwiches cut down the middle but she thought they should be cut diagonally so that's how she did it. Now that I look back on it you'd think she could have thrown me a bone!

"I ate the same damn thing every day for six years: peanut butter and jelly, an apple, and apple juice."

IMMIGRANT CURIOSITY: "WHAT IS A CORN DOG?"

DIEP TRAN

Chef | Cerritos, California, 1972

I HAD JUST TURNED SIX WHEN I CAME TO THE US WITH FIVE OTHER refugee families. We moved from a refugee camp in Thailand to Aurora, Colorado. Colorado was too cold for us. We heard from other refugees in our network that California was warm so we went there.

No one wanted to be apart, so the grown-ups decided it was best if we all lived together in one house. We pooled our money together and found a five-bedroom house for five families. Multigenerational living didn't feel unusual to us. I had my great-grandmother, my grandmother, my aunts and uncles, and us—four generations all together. I grew up in my own little village.

I never understood the idea of a nuclear family. I remember having to do a school project where we had to talk about our family tree. The teachers asked me how many people were in my family. I said, "Fifty, that I know of?" The teachers didn't understand. They told me to write about my *nuclear* family. I asked what that was, and they said, "You know, your mom and dad." Well, my mom's dead, my dad's not here but this *is* my family! The idea that it didn't "count" was strange to me.

We were refugees on public assistance. We never brought lunch from home; we ate the free lunch at school. We were on Medicaid, food stamps, and the government health plan.

Lunch was super fun. American menus to my eyes were so fanciful. For example, beans and franks: what are *beans* and what are *franks*? Corn dogs, what is a *corn dog*? It was never just "beef" or something I could understand. We loved it because it felt so unusual and exotic. You could tell who was American-born because they would deride the food, but we liked it. Everything felt luxurious and wasteful. There were these little ketchup packets you would use and then throw away, or sometimes not even use. Fruit cocktail I loved

and was familiar with from refugee camp. The only thing I really didn't like was the chocolate milk they served. I was used to condensed milk with sugar in it. I would give that away to my American-born friends since they liked it.

We did register that other kids didn't like the cafeteria food the way we did, but we didn't have that experience of shame because we weren't isolated: we had our own community. In many ways that was a blessing and a curse—the family gave support but was also always in your business. It was hard to be an individual.

The household would expand and contract based on what families came and left, but there were probably fifteen kids all together at the height. All my relatives started restaurants. Relatives would join the household for a rent-free place to live while they put all their resources into the restaurant. When you were ready, you moved out. It didn't feel like we were living in squalor or anything, it felt like a commune, except usually people in communes aren't all relatives.

My grandmother's generation was always in transition. They moved many times—moving to America was already the second or third big transition. I think about Vietnamese immigrants who fled their country, then lived through Katrina or the BP oil spill. They already had so much experience dealing with catastrophe. They were used to having to constantly rebuild and move. I have a lot of compassion for that generation.

My youngest cousin was picked on because she was small and only spoke Vietnamese. We were very offended. We asked her to identify the boy who had bullied her and all fifteen of us confronted him. We got right in his face and yelled at him in Vietnamese. He didn't understand a word we said but our point was clear. It felt good. She was so tiny and cute, how could you pick on that? We called her Baby. Nobody picks on Baby.

We got a lot of hate, but we didn't always understand it as that. It wasn't until I got to high school that I understood that to egg and TP someone's house was an act of aggression. Every weekend growing up we'd have egg on our door and toilet paper thrown all over the tree outside. We'd wake up to it and say, "Wow, Americans are so rich, they just throw good-ass eggs and toilet paper—so wasteful!"

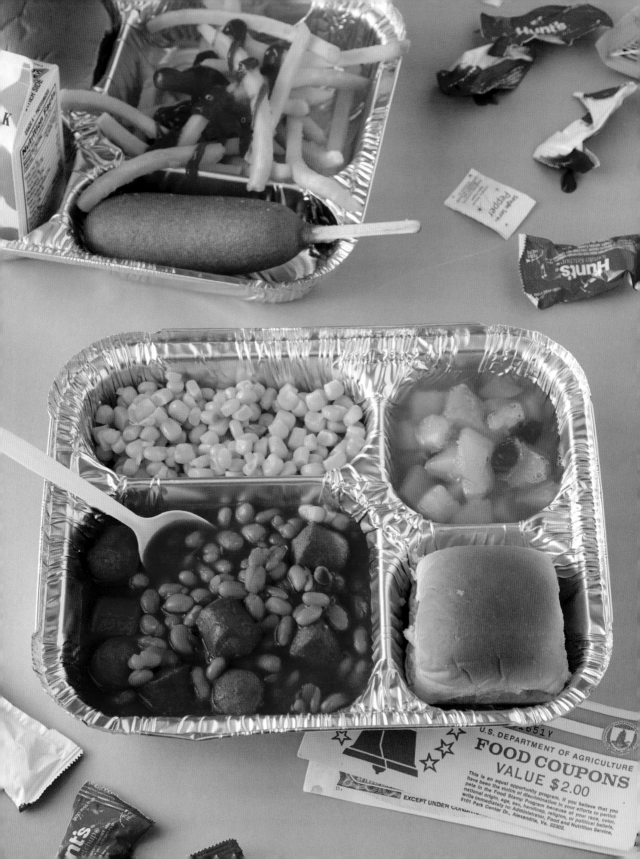

INDIAN FOOD PRIDE AND SHAME

PADMA LAKSHMI

Author and Host/Executive Producer of Bravo's *Top Chef*
Chennai, India, and New York, New York, 1970

———————

I GREW UP PARTLY IN NEW YORK AND PARTLY IN INDIA, BUT I ATE THE same lunch in both places for a long time. In India, my food was fine and normal, but when I was in America it was weird. Everyone else had baloney sandwiches with the crusts cut off or these little peanut butter and jellies, and I had this funky Indian food that looked weird and smelled very strong.

Kids would taunt me with all the mean-kid things you'd expect; they were not shy at all. They'd say, "Ewww, what is that? It smells! It looks like poop!" Especially the lentils. I mean, I love lentils but they're not pretty.

A few kids would have Tupperwares of food but for the most part they hardly had any leftovers, they all had sandwiches. My mom took a lot more effort to make those wholesome lunches. I was embarrassed to eat my lunch in front of other kids but I loved *idlis* and I loved coconut chutney: I still do. I really did not like sandwiches.

It's funny because my daughter has grown up in America but she doesn't like sandwiches, either. She gets lunch from school but we have to send a snack. We pack her grapes and tangerines, carrots and celery sticks, broccoli and cauliflower, then we do crackers and goldfish, or yogurt and cheese sticks. We try to have a little bit of everything. Her snack box looks as big as my lunch box!

If I have to pack her lunch for a field-trip day I will pack her things like pomegranate and pearl-mozzarella salad with fresh mint and balsamic and oil. I'm over-zealous when I pack her food because I don't ever want her to have lunch envy. I have more resources and time on my hands than my mother had as a full-time nurse so I will make special food and write little notes. I think it's my personal history coming back with a vengeance, trying to rectify all that humiliation I faced and pour that into the food I pack my daughter.

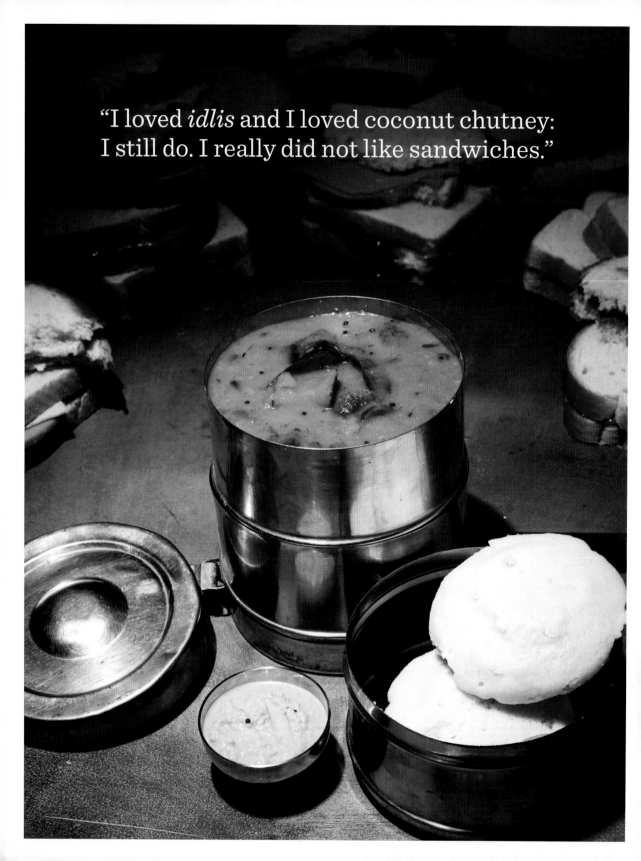

"I loved *idlis* and I loved coconut chutney: I still do. I really did not like sandwiches."

SPECIAL TIME WITH DAD

RENA UVILLER

Retired New York State Supreme Court Judge
Detroit, Michigan, 1937

EVERYONE WENT HOME FOR LUNCH; EVEN AT AGE SIX I WALKED TO and from school by myself, or with my friend. We lived in a Jewish immigrant enclave with mostly single-family homes. It was a developing neighborhood; we'd walk by some open fields and only one big intersection with a crossing guard.

My parents came here with nothing: my mother from Belarus, my father from Poland. We had a great community; relatives all lived within a block or two.

My father had a little shop in downtown Detroit and my mother would sometimes go and relieve him so he could come home for a home-cooked lunch. That would be such a thrill for me to get to have lunch with my dad. We'd always sit in the breakfast nook and we'd talk but he'd also read the paper. I ate grilled cheese a lot, sometimes with chocolate milk because they were always trying to fatten me up since I was such a skinny kid.

HAWAIIAN SPAM MUSUBI

NATALIE WEBSTER

Columnist and Podcast Host | Honolulu, Oahu, Hawaii, 1970

MOSTLY I WOULD EAT THE LUNCH THAT WAS SERVED IN SCHOOL, AS my mom wasn't really into making lunches for me. On the days I did bring lunch, it was usually Spam Musubi, which is a classic Hawaiian snack. You take nori paper, put molded rice on it, add Spam on top and wrap it all in there.

Spam Musubi pretty much covers it all, but if the neighbors gave us fruit from their trees my mom would sometimes throw that in. Clementines or lychees would be fine, but sometimes she'd pack a whole mango. I'd always tell her, how am I supposed to open a whole mango at school—no one would give me a sharp knife! My mom, God rest her soul, was not exactly Mom-of-the-Year on this kind of stuff, she'd be the first to admit it. She worked full time, that woman was not about to peel and slice fruit for me. The concept of buying fruit was new to me when I moved to the mainland as we always just ate what was around and in-season. You can't give mangos away in Hawaii!

If my southern grandma were there, she'd pack me a baloney sandwich on white bread with mayo. This was not as popular as Spam, but she didn't understand that. Hawaii was very Asian; we don't eat baloney.

Spam became hugely popular in Hawaii during the war [World War II]. The American government brought it over to feed the soldiers because there was a meat shortage, but it really took off with the locals. It is a *staple*. Everyone eats it. At every single restaurant in Hawaii you are going to be eating rice with every meal and often Spam is on the menu as well. If you go on a picnic, you take Spam Musubi. If you need a snack, it's Spam Musubi. A packed lunch? Spam Musubi. You can pick them up at the 7-Eleven or any gas station or grocery store. It's easier than making a sandwich and you don't have to refrigerate it.

On days I didn't bring food from home, I'd eat the cafeteria school lunch. Despite its ubiquitous presence, the school didn't serve Spam, which I thought was strange. This was because Hawaiian public schools were created and

"If you go on a picnic, you take Spam Musubi. If you need a snack, it's Spam Musubi. A packed lunch? Spam Musubi."

run by the US government. We were not taught Hawaiian history, you were only taught mainland American history. The way Hawaii became a state is a very different story than what's taught in American history. The only way you'd learn that would be from your family or if you went to private school.

Typically the school lunches were not at all the kind of food we'd usually have at home. Instead I remember thick-crust pizza and canned prunes. I *loved* the prunes. The other kids wouldn't eat them because they were all convinced they'd get diarrhea but I loved them and would eat everyone's prunes. When I think back on it, it's probably a good thing I was eating all those prunes because I never ate vegetables. Veggies were just not a big thing in my house. If we had them, they were from a can. I didn't know that asparagus could be crunchy until I was in my thirties and I actually started learning to cook.

It's funny because I've now lived most of my adult life in Minnesota, which is actually the birthplace of Spam. This impresses my Hawaiian family the most. There's a Spam museum here in Minnesota, which they think is the coolest thing.

Ironically, however, people born here in Minnesota make fun of Spam. They call it "mystery meat" and most won't touch it. It only has about five ingredients—which is fewer than a lot of processed meats we eat. And it's purely pork! I've found myself in a position to defend it here. My own kids grew up eating it for breakfast. They'd have friends sleep over and 90 percent of those kids had never tried it. "You guys, it's from here!" I'd tell them. Then I'd make them try it. I spent many years where once a year I'd come to the school during the International Food Fair and "introduce" Spam to the Minnesotan kids as a Hawaiian food.

I'm a clean eater, my diet is primarily paleo and hormone-free, and I eat Spam.

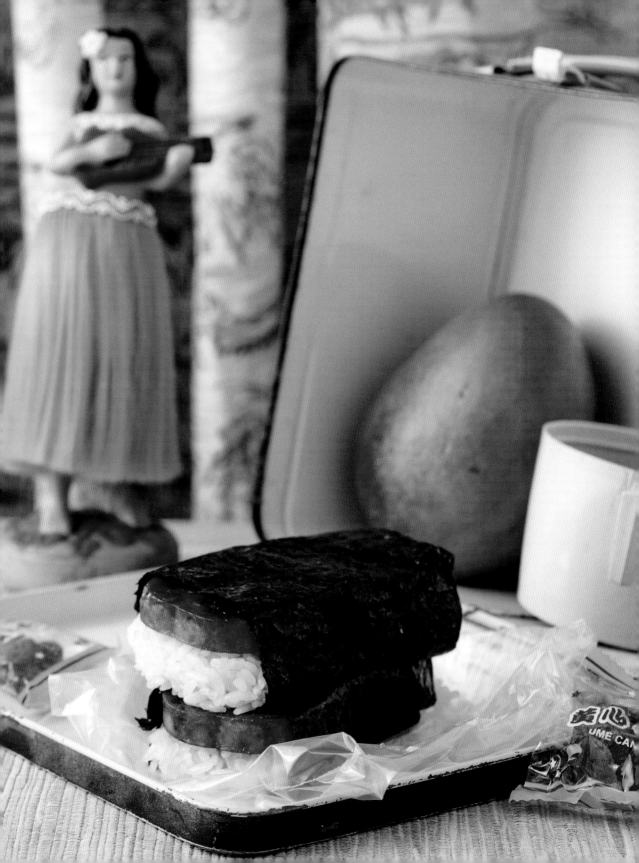

MOM'S LUNCHABLES

ERIC ROGERS

Photographer, Videographer, Art Director
North Chicago, Illinois, 1995

I ALTERNATED BETWEEN PACKED LUNCH AND HOT LUNCH. I SOMETIMES hated the hot lunch; it was always just gross and never held a candle to packed lunches. My favorite lunch my mom would make was homemade Lunchables. She would cut little circles out of baloney and they just tasted better than the real thing. We were in a tough financial spot around this time, so the switching between packed and hot lunches was probably more financially motivated than I realized at the time.

CANNED SALMON WITH VINEGAR

SKID MOFFET

Gallery Owner, Sandal Maker, and Pattern Maker in NYC Garment District
Brockton, Massachusetts, 1925–2018

———————

MY FATHER WAS A BAKER, SO I HAD THE BEST DAMN BREAD YOU EVER had. My father smelled of bread, he was delicious. The police used to give him rides home from the bakery; there was a real community back then.

You took lunch mostly according to your income. Whatever you had at home, you made a lunch of it. I used to bring some really terrible stuff, like onions and vinegar in my canned salmon. I wasn't into the sweet stuff. No peanut butter and jelly and all that, I was the kind of kid who would screw up my face and chew raw rhubarb and those sour tendrils of grapevines.

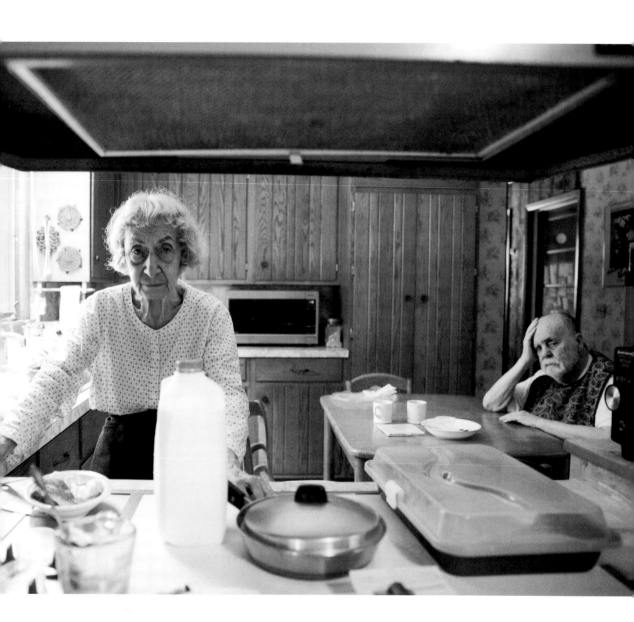

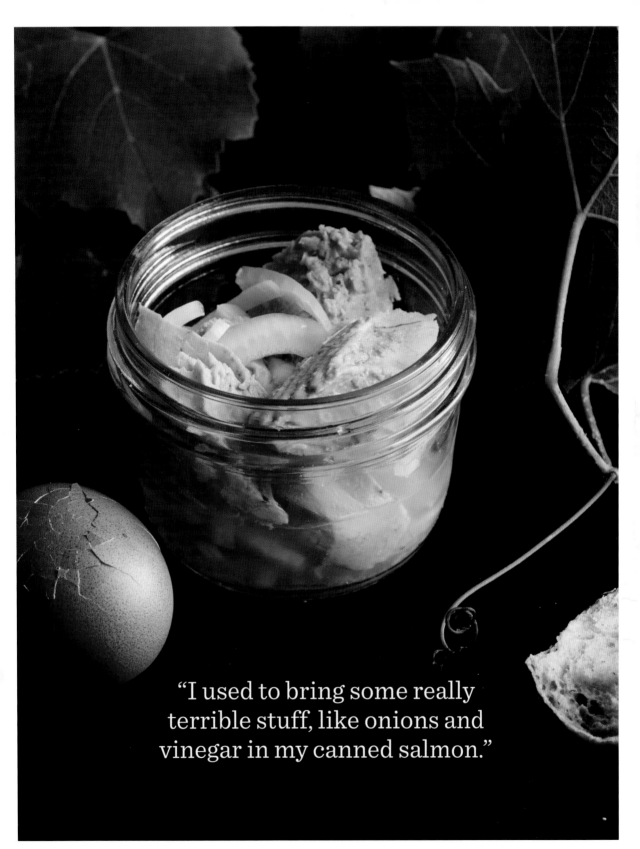

"I used to bring some really terrible stuff, like onions and vinegar in my canned salmon."

SELLING PHOTOS OF MY BROTHER TO BUY JUNK FOOD

DANIELA PEREZ

Graphic Designer, Caracas, Venezuela, 1981

———————

I WENT TO A CATHOLIC SCHOOL THAT WAS ALL GIRLS ON ONE SIDE and all boys on the other. My mom used to pack us healthy food. She'd make triangle *arepas* filled with ham and cheese or Diablitos (Venezuelan deviled ham). I'd also get fruit and water. Every single day I'd have an apple. Sometimes I'd bring the apple back and she'd say, "You have to eat it, an apple a day to keep the doctor away," but I hated apples. I had a dream at one point that there were apples everywhere and I was going crazy.

The cafeteria at school served everything fried. It wasn't healthy but it was so good. I loved their *tequeñones*—which were fried cheese sticks—the empanadas, these little packaged cookies called Chocochitas, and Malta drink. Of course my mom never gave me money to buy any of that. But I was resourceful.

My brother was younger than me, and super cute. Two younger girls from school were completely in love with him. I used to have those little wallet-sized pictures of my family. One day one of the girls saw the photo I had of my brother and said, "Oh my god, I love that picture, can I have it?" I said OK, if she paid me. That week every day I had lunch twice, my mom's and then the cafeteria's. I did that three or four times, but then I stopped because I felt bad.

My mom used to fly to New York for work. When she came back she'd bring me colorful pencils as souvenirs. I'd get cartoon characters like Hello Kitty, and rainbow-shiny colored ones. You couldn't get that kind of thing in Venezuela, only the basic yellow ones. I'd sell those, too, to get more money for the cafeteria food. I had my own little business at school and my mom never found out.

My brother found out about me selling his picture when we were adults, not too long ago. He said, "You owe me money!" My mom was shocked and said what if the girls had done something with those pictures. But I knew they wouldn't have, they were too scared to even talk to him.

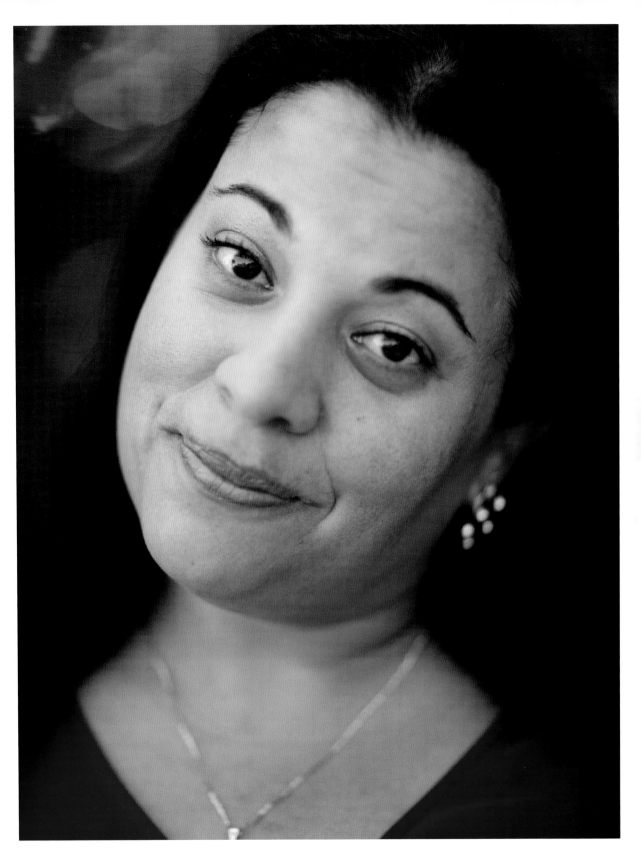

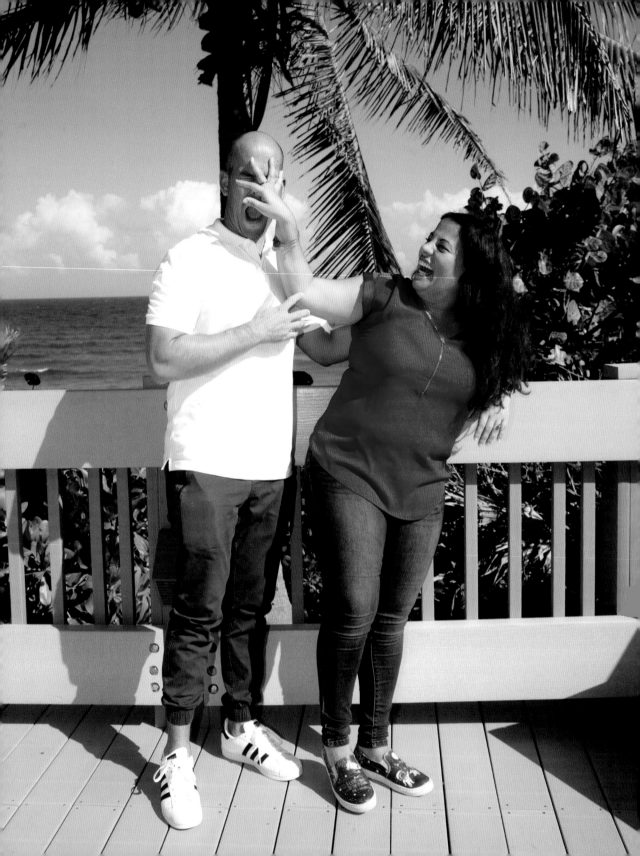

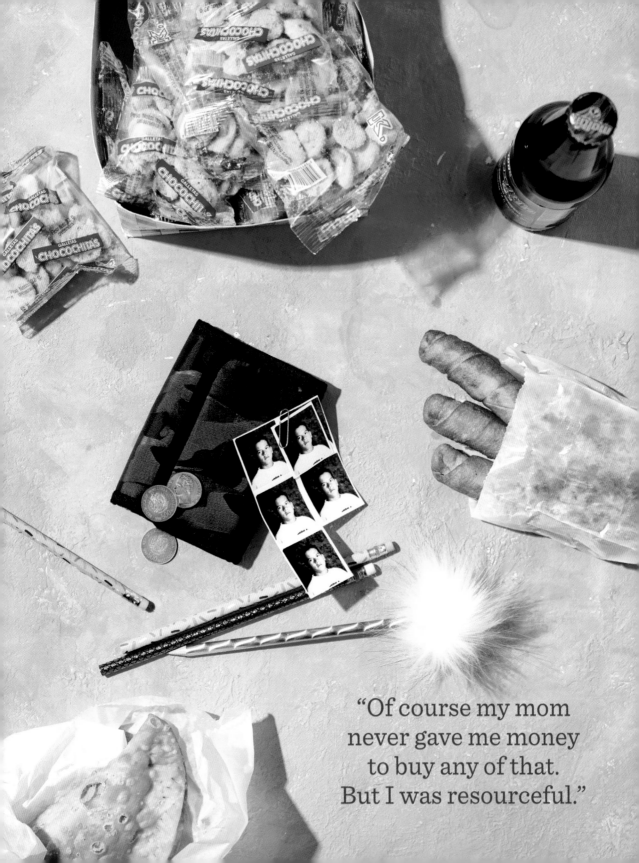

"Of course my mom never gave me money to buy any of that. But I was resourceful."

ITALIAN MOTHER'S LUNCH OVERLOAD

LAURA VITALE

Television Host, Cookbook Author, and YouTube Personality
Quarto, Italy, 1986

WE WENT TO SCHOOL FROM 8 A.M. TO 1 P.M., MONDAY THROUGH Saturday. Lunch was the biggest meal of our day, and you usually ate at home with your family. Small businesses would close up shop from 1 to 4 p.m. People would go home to eat, take a little nap, and then go back to work. Not many women worked where I came from.

Three days a week, however, we'd have play practice after school. On those days, my mom used to pack me lunch. We still talk about this story all the time in my family because she used to pack me these huge four-course meals. She would pack a pasta entree, a chicken cutlet, a small sandwich with mozzarella and prosciutto, and fruit. There was no way a small girl like me could eat that all in thirty minutes! I would trade with friends or give it away.

When my mom found out about this I got in big trouble. She started coming to school every day and making me sit by the teacher's desk at lunchtime. She'd pretend to leave but then would sit on the other side of the glass door in her sweatpants and high heels and stare at me to make sure I was eating. This went on for a solid two weeks; it was mortifying. Every day I would literally cry because I would be so embarrassed. After weeks of pleading we finally came to a compromise. She scaled my lunch down to two courses, which I would eat completely. I was so relieved.

To this day, my mom and I talk almost every day. The first thing she asks when she calls is usually "Did you eat today?" Yes, Mom, I ate today.

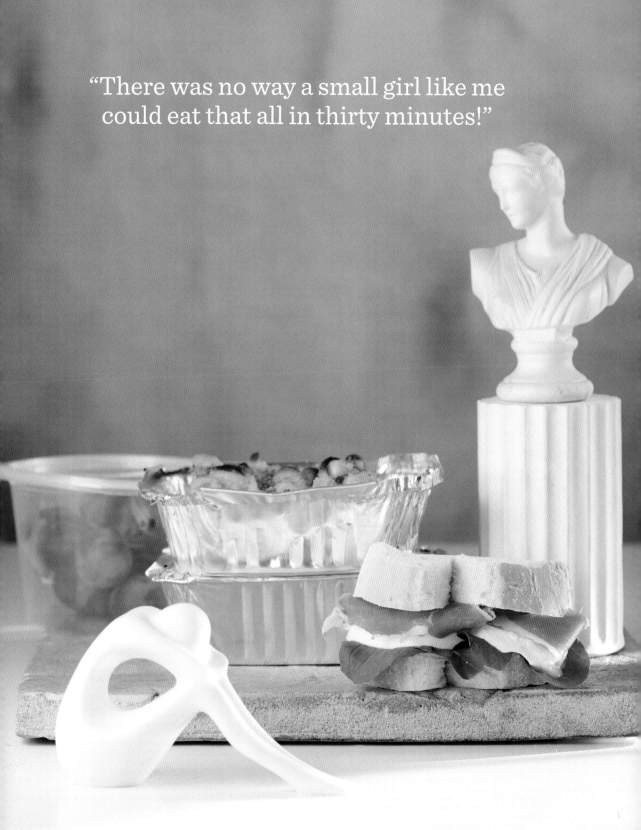

"There was no way a small girl like me could eat that all in thirty minutes!"

YOUNG PRIDE AND AN EMPTY PAPER BAG

GEORGE FOREMAN

Former Professional Boxer, Two-Time World Heavyweight Champion,
Olympic Gold Medalist, Ordained Minister, Author,
and Entrepreneur | Fifth Ward, Houston, Texas, 1949

VIOLENCE IS ALL BUILT AROUND HUNGER.

Growing up I was always hungry. I didn't have a good time going to school. Even on a good day there was only going to be one meal. My mom had to get up early and go to work and we went to school without breakfast or lunch. Coming home from school—that was the time there would be a meal. And that meal would have to last you until the next day about the same time.

Occasionally, something bright would happen and we would take a lunch to school—a paper-thin slice of lunchmeat between two plain pieces of sandwich bread. I would daydream about a little mayo.

Some of my happiest days as a kid were the days when I had just finished eating. That meant I could play all day. I could jump and run and have fun. On the days when I didn't have enough food there was always a reason to start or finish a fight.

As a kid so much violence was built around pure hunger, and so much joy was built around having a tasty meal.

Third grade is when you start looking around and trying to make yourself handsome. It's also when you try to conceal that you don't have anything. I'd find an old greasy paper bag at home, and I'd blow it up and carry it with me to school. I'd have this fake bag so that kids didn't know that I didn't have a lunch. At lunchtime I'd say "I ate it on the way to school" or "Oh, I ate it already" and fold it back up. That bag was precious because you needed it again; you couldn't just throw it away like they did their bags. I don't know how a person can be so deprived and poor but then have so much pride.

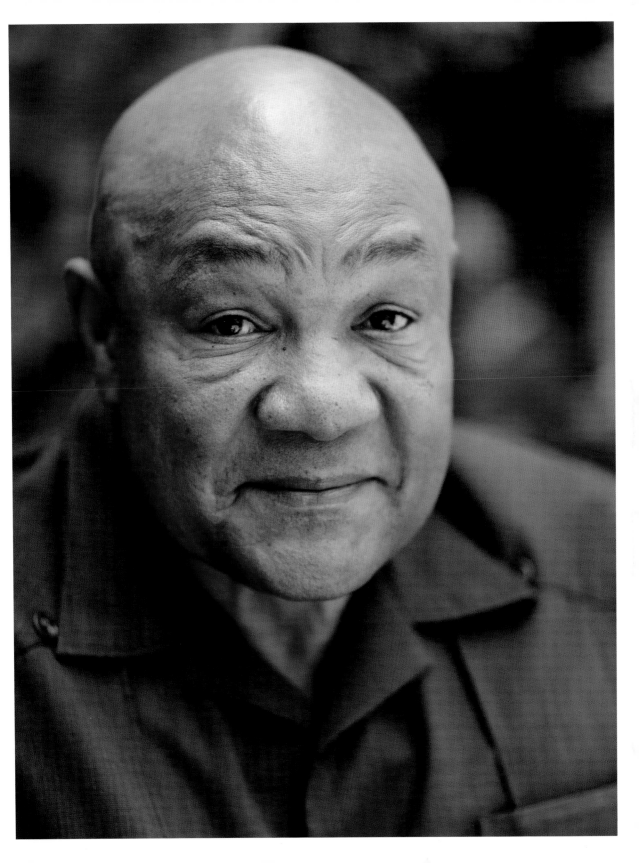

Lunch at school was twenty-six cents, I think. The kids would pay and they'd get two veggies, a piece of bread, and some meat. That was a beautiful sight to see and I *never* had one of those. I *never* had one. You'd get a little cup of milk with it and I always wished I could have one. I went all through elementary school never having one. My mom just never could afford to give me that kind of money. There were some free lunches going on but it was a real political thing. This had to be arranged, that had to be arranged, and for some reason my mom never could qualify.

I was number five of seven kids. My two older sisters dropped out of school pretty early. One was responsible for babysitting, and a kid was always sick. At about age twelve or thirteen my oldest sister didn't go to school anymore. She just stayed around the house.

The girl right after her, it was about the same thing.

I kept playing like I was going to school but after a while I didn't go either. When you don't have clothes to wear and you don't have food to eat, it's embarrassing and you start playing hooky.

I'd leave my home every day like the best boy in the world. My mother would go off to work and I'd go to the school with all the kids. Then I'd make my circle around into the woods for a little bit, head back home, climb back in my window and go to sleep. At about 2:30 I'd climb out of the window, go back through the woods to the school and walk back home on the front street as if I was a nice schoolboy.

If you asked me, what caused this, what caused that, I can tell you: Hunger. Hunger.

Hunger was the thing that motivated me period. I was always searching for enough to eat.

I started boxing so I could get more food. When I see kids now I have this thing where I feel responsible to feed them. I'm always asking, "You want some more? You want some more?" You never get full.

I hear now that some schools have free lunch and even free breakfast. That's the most wonderful thing that could ever happen to a human being. If it's free for everyone, no one knows who can afford and who cannot. You might think they don't need to offer free lunch to everyone because some kids don't need it, but we do need it just so the ones who really need it don't get

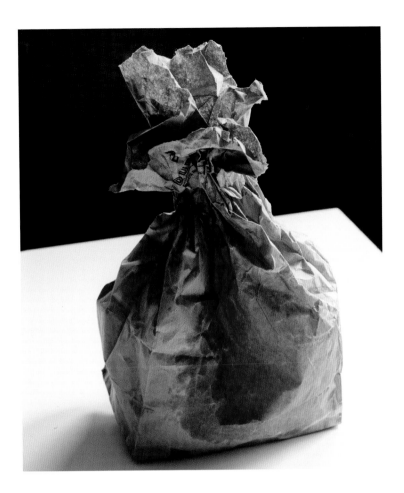

embarrassed. Pride jumps up around age seven; you might starve because you don't want to let people know what you don't have.

There was no way I could have asked a kid next to me if I could have a piece of their sandwich. I wanted to so bad. Some kids would only eat half their sandwich at lunch and leave it on their tray. I was hungry but I just couldn't ask, "May I have that piece?" I just couldn't do it. When you're seven or eight you think they are going to laugh at you and tell the girl sitting two seats away, "He's asking for my sandwich." No, you just couldn't do it.

To me it seemed like everyone had but me. Looking back, and talking to people later, I realized so many kids had to hide their hunger. No one wanted to say a word.

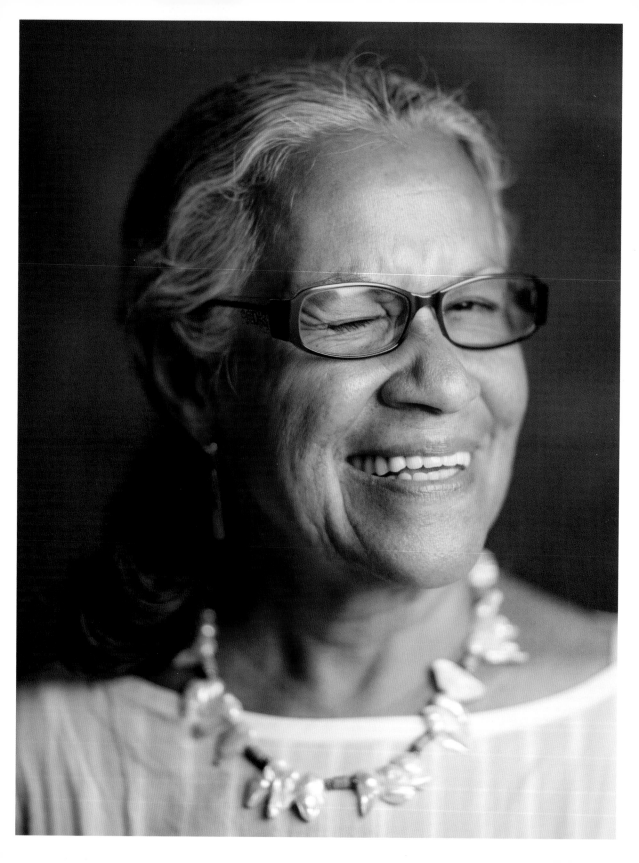

PUERTO RICAN PLAYGROUND DELIVERY

JOSEPHINE MANGUAL

Teacher | New York, New York, 1954

I GREW UP IN A BLACK AND PUERTO RICAN NEIGHBORHOOD IN HARLEM.
Puerto Ricans don't eat cold lunch so my mom and a small group of other
Puerto Rican mothers would bring us piping-hot food in *fiambreras* [stacked
tins] every day.

They weren't allowed into school so we wouldn't eat during the lunchtime
in the cafeteria. Instead, we'd wait to eat at recess. That's when our moth-
ers would meet us in the schoolyard with our hot food. My mother always
brought extra because everyone loved her cooking and would flock around
us. She'd bring *plátanos*, rice, beans, sometimes some meat, and a fork from
home. She'd also always have a dessert, usually *limbers*, which are like fruit
popsicles. It was a social time for the mothers, too. Everyone enjoyed it.

"My mother always brought extra
because everyone loved her cooking
and would flock around us."

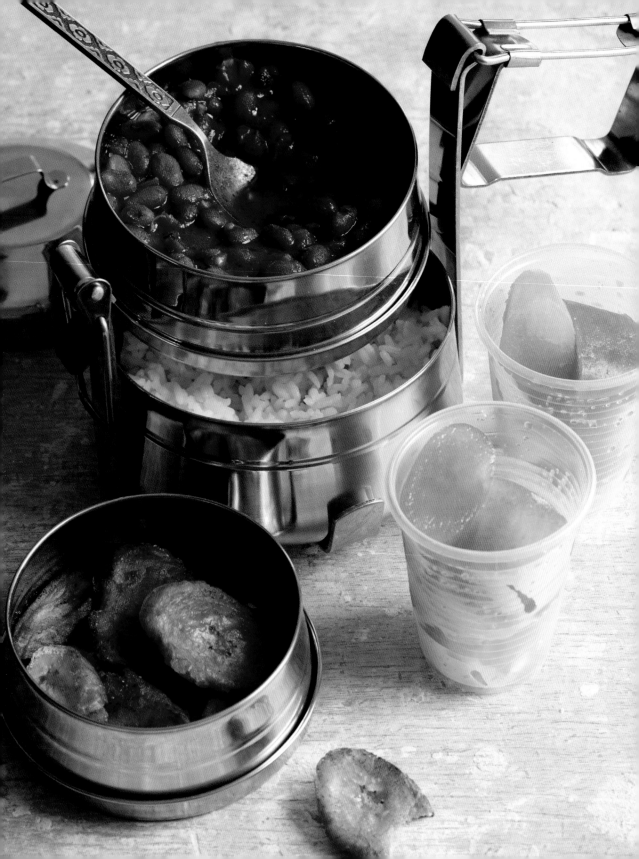

SLOPPY EIGHTIES CAFETERIA

ARIANA MANGUAL

(JOSEPHINE MANGUAL'S DAUGHTER)

Professor of Education | Inwood (Manhattan), New York 1980

I HADN'T HEARD THE STORY OF MY GRANDMOTHER COMING TO THE playground with food until my mom was interviewed for this book. I loved learning about it! I can imagine the women of my grandmother's generation walking the few blocks to school and standing at the edge of the gate to make sure their kids were getting nutrition from home.

Twenty-five years later, when I was going to school, people's jobs had changed and the relationship to the neighborhood school was different. When I was little, I commuted to school from upper Manhattan to East Harlem, near where my mom worked. Ironically, I commuted to a neighborhood that was largely Puerto Rican and African American but we were not near home, so bringing food during the day wasn't possible.

Everyone at my school got the cafeteria lunch. I remember the sense of scale—being a little person and filing down to this huge cafeteria with big linoleum tiles. I remember the off-peach colored trays and the big metal spoons the black and Puerto Rican lunch ladies wielded. The lunch ladies were always really hot from the kitchen. They were friendly, but they also meant business—you didn't get in their way. I remember being fascinated by the ill-fitting plastic gloves and the hairnets that made diamond patterns in their hair.

There's a mainstream image of immigrant parents not being as involved in their kids' schooling because of language and cultural barriers, but what I've seen from my grandmother's example and also the immigrant families I work with now as a teacher, is that they find creative ways to be involved and supportive of education. My grandmother maybe couldn't help with homework but she could be sure my mom was getting a good hot lunch that would support learning. Over multiple generations, immigrant culture starts to shift. My own mother had gained trust in American institutions and

> "I remember the sense
> of scale—being a little person
> and filing down to this huge
> cafeteria with big linoleum tiles."

cafeteria food by the time she was a parent. She was a literacy coach and early intervention specialist, so, she knew very well how to help me with my homework and engage in parent-teacher conferences. Her way of supporting my education was different from that of her mother's, but they both leveraged what they had.

SWEDISH CAFETERIA HUSMANSKOST

MARCUS SAMUELSSON

Chef and Restaurateur | Gothenburg, Sweden, 1971

SCHOOL LUNCH IS ONE OF THE CORE REASONS I BECAME A CHEF.
I got food knowledge from basically three different aspects of life: my grandmother's cooking at home, my family's access to nature—fishing for cod or mackerel or picking lingonberries in the woods—and then my school lunches. The school lunches helped me set up an appreciation for taste, even the stuff I didn't like. There was a salad bar every day, there was milk or water, hard crisp bread, and then there was the daily lunch. Lunch could be anything from Swedish meatballs to roasted chicken salad, with vegetables always available. The food was hearty and followed the old-school Swedish ritual of *husmanskost*, which was rustic and traditional with local ingredients.

The lunchroom is where everything happened. From fights to fun, getting to know kids from two years up and two down—that's where you learned there's a social aspect to dining. I don't think that part's very different from American schools. But food insecurity doesn't happen in Sweden. Everyone gets the same lunch; there weren't really options. Parents pay for it indirectly through their taxes but there's no direct cost at school. The most popular meals were when they started branching out to chili con carne, or spaghetti Bolognese or later pizza. Any time they broke out of the Scandi-menu it was fun. As we became more diverse the food represented that. Sometimes they'd do savory pancakes with slow roasted pork and fresh lingonberry jam, and that was very popular, too.

We had to work and help out, clearing trays every day. We each had to work one day a year helping to set up so we knew what it took, and understood what the people who worked there were doing for us. The cafeteria workers were an extension of the teachers; they probably saw more than the teachers because it was a free time for the kids. They'd report everything back.

"The lunchroom is where everything happened."

I learned a sense of taste in those meals. As I got older, I also started to differentiate. When I was twelve or thirteen, I started to realize how well pre- pared my grandmother's food was. If she made fish meatballs they wouldn't be perfectly round because they didn't come from a can—she was making them by hand. There was this otherness that I started to appreciate. Her sauces and gravies were real. But if you cook for six hundred kids at school, the process has to change.

You can't even compare American school lunches with Swedish ones. Swe- den is a smaller country, with smaller schools, high taxes, and we rarely go to war. That means we have money to spend on education and food education. If you ask the kids there right now they will still complain the food is not good because that's just what kids do but I have the comparables to know it is excellent.

I think school lunches even in Ethiopia, where my biological family was from, are much better than in America. In Ethiopia they serve injera bread so you're starting with a heritage grain, all organic. The school meals are mostly vegetarian, with chickpea flour, beet stew, and things like that. It's not in every school because they can't all afford it, but fundamentally you start with an organic, local process of real food.

When it comes to technology and industry in the United States, we are probably top five, but when it comes to school lunch there are probably 180 countries we could learn from. We do a really good job prioritizing those who have, but we don't do a good job prioritizing those who don't have.

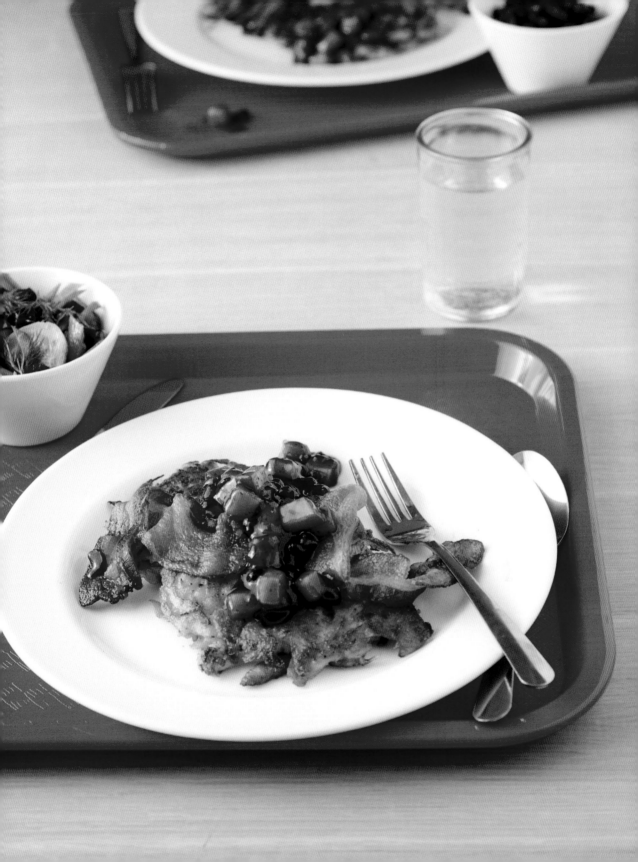

HEALTH FOOD ADVOCATE
DAPHNE OZ

Natural Foods Chef, Television Host,
New York Times Bestselling Author, Daughter of Dr. Mehmet Oz
Cliffside Park, New Jersey, 1986

I BROUGHT MY LUNCH FROM HOME EVERY DAY UNTIL HIGH SCHOOL.
I loved my lunch. My mom has been vegetarian since she was thirteen so the
lunches she packed me looked really different than everyone else's. We were
definitely a crusts-on family. I loved getting sliced green olives and cream
cheese on Ezekiel bread, or a Garden Burger on toast with lettuce and
tomato. My all-time favorite sandwich was whole-grain toast, Heinz mayo,
Bull's-Eye barbeque sauce, and pulled Armenian string cheese with nigella
seeds in it. This is still one of my favorite sandwiches.

When I was little, I went to a Montessori school in Fort Lee, New Jersey,
which was in a largely Asian community. I still have a vivid memory of sitting
down next to my best friend who would have fresh kappa maki rolls, shelled
edamame, and cut fresh mango in a little box. The balance and beauty of
the Japanese lunch struck me even back then—it looked so amazing. I also
remember so clearly the kids with Lunchables. I remember wishing that I
could eat the canned tuna with the squeeze packet of mayonnaise and the
Ritz crackers. Now thinking about it, it's so unappetizing, but they really cap-
tured something about the child brain that loves compartmentalizing and
being able to put together your own food.

My dad is so good at so many things, but he was not the one packing our
school lunches. That was thankfully all my mom.

When I was growing up, my dad was a highly accomplished, awarded
cardio-thoracic surgeon. He was Dr. Oz, and was excellent at what he did,
but he wasn't "America's Doctor" at that point. He didn't start appearing on
Oprah until I was in high school.

My dad, uncle, and both of my grandfathers are surgeons, so our family is
grounded in Western medicine. At the same time, my mother and her mother

are both deep into Eastern practices. They studied nutrition and holistic and complementary medicine, and were focused on supporting the soil of the body to help it avoid sickness rather than only on treating disease once it was there. I think having a doctor in the family actually makes you a little less hyper-cautious. My parents made sure 80-90 percent of what we put into our bodies was good, healthy food that supported our health and growth. And then we would still get to splurge and have treats, too. In general, our family seized any opportunity to create celebrations and memories around food. My mom cooked most nights (we usually ate after 9 p.m. when my dad would get home from the hospital) and we had dinner parties on the weekends. All our birthday cakes were homemade and heavenly.

It was really fun growing up watching my dad eat. He's very fit now but he used to be a big football player—jacked and enormous. We would call him The Garbage Truck because he would eat all the leftovers and everything that was available. If he ordered fresh fish at a restaurant he would insist they bring out the whole thing and he'd carve it off the bone and even eat the eyeballs. He would eat every cut of meat. He was never afraid of anything.

It was interesting growing up with a mother who was vegetarian before that was really part of the zeitgeist and a father who was such an adventurous eater. My mom had to experiment with Indian, Asian, Middle Eastern, and other flavors as a way to make vegetarian food interesting and exciting for my very adventurous, omnivorous father. I credit that extremely exotic and flavorful dinner table with developing my own love of experimenting with food and not being afraid to try new things.

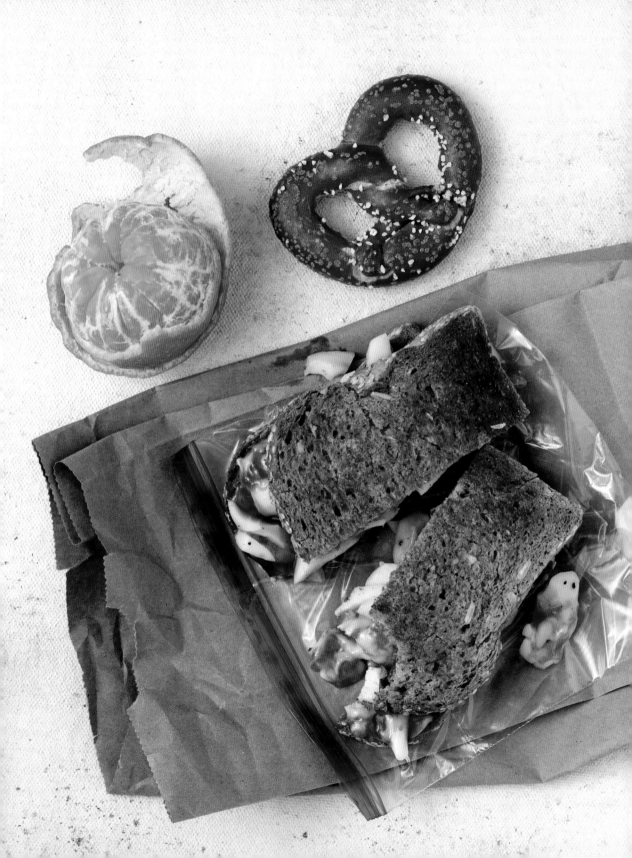

JUNK FOOD FRENZY

KELLI KIKCIO

Tattoo Artist | Saskatoon, Saskatchewan, Canada, 1989

WE ATE OUR LUNCHES FROM HOME IN THE SCHOOL SCIENCE ROOM—THERE was no school cafeteria. In American movies I'd see lunch ladies and cafeterias and always thought that looked cool.

My parents were PE teachers with kinesiology backgrounds so we got super healthy whole wheat sandwich–type lunches. My brother and I were always disappointed. We would try to trade with kids who had pizza pops and Dunkaroos. But no kid wants your grapes and strawberries. I remember thinking my parents were so cruel because we had no junk food, but now that I'm older I get where they were coming from.

Once a month lunch in the gymnasium we'd have Hot Lunches as a school fundraiser. I really looked forward to those meals. They'd have a staff volleyball game and the kids would eat and watch. You'd go to the window in the gym and purchase everything. Everything was really cheap so my $4 would go a long way. I was a little seven-year-old but I'd pile on hot dogs, donuts, Beep Orange Drink, and as much chocolate milk as I could balance.

When I didn't have limitations, I basically had no restraint or self-control. Because I never got sweets or junk food at home, if I saw an opportunity I took it. At Sunday school when you were supposed to have one cookie I'd eat sixty if I could get away with it . . . inevitably making myself sick. Part of it was because of the strict limitations as home but part was my personality. My brother would be able to only have one cookie.

When I was sixteen and could drive with my friends, I discovered McDonald's. There was a month in my life where I went there secretly on my own probably four times a week. It was like I was on that show *SuperSize Me*; I gained at least ten pounds. I got so sick of it after that but I couldn't stop myself at first.

When I went away to university and had none of my parents' restrictions I had way too much candy and alcohol. As an adult now, I often think about the restrictions my parents had and what kind of a parent I would try to be if I ever had kids. There has to be a balance with what you eat and when you get treats.

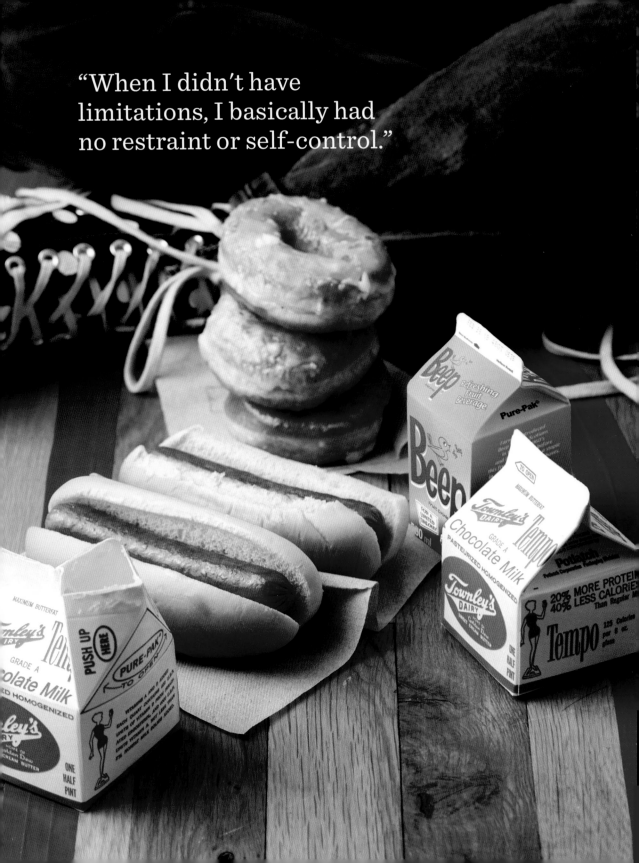

"When I didn't have limitations, I basically had no restraint or self-control."

INDIAN HOT POCKETS

TASNEEM CHERRY

Fashion Designer | Clemington, New Jersey, 1979

———

MY INDIAN IMMIGRANT MOTHER TAUGHT US THAT AMERICAN LUNCHMEAT was not made from real meat, so I didn't try it until college.

She didn't believe in the lunch they served at school and packed our lunches through high school. She would put two pieces of bread and Indian leftovers in a grilling machine to make homemade hot pockets, which she'd wrap in foil. My sister and I would get identical lunches, packed in a brown paper bag, usually with fruit or fruit leather. We desperately wanted the school lunch; our mother would sometimes concede on pizza day, as long as there was no meat.

> "She would put two pieces of bread and Indian leftovers in a grilling machine to make homemade hot pockets, which she'd wrap in foil."

DEAL WITH MOM
SURAIYA CHERRY
(TASNEEM CHERRY'S DAUGHTER)

West Orange, New Jersey, Age Six at Time of Interview

MY MOM AND I HAVE A DEAL. I DON'T TAKE THE CHOCOLATE MILK AT school and she packs a little treat as part of my lunch. It's always my favorite part. Sometimes I eat it first and sometimes last.

NOTHING TO TRADE
SAM KASS

Former White House Chef and Senior Policy Advisor for Nutrition,
Executive Director of First Lady Michelle Obama's "Let's Move!"
Campaign, Author and Entrepreneur
Chicago, Illinois, 1980

THE DEFINING MEMORY OF SCHOOL LUNCH FOR ME WAS THE FACT
that I never had anything to trade. My parents were pretty healthy so I'd
have a turkey sandwich with American cheese, applesauce, a piece of fruit,
and a juice box. *Maybe* a mozzarella stick, too, but that was it. And that
had no value on the market. I didn't have any fruit roll-ups, no gummies,
no brownies, no cookies. Lunch period was like an auction house or an old
marketplace in Cairo or something. Everyone got there and then the bar-
gaining began.

In my memory everybody had something to work with except me. Every
kid had some good item to trade and I had fucking applesauce. I think at a
certain point I convinced my parents to put a single Chips Ahoy cookie in
there, but even that didn't have much value; everyone had chocolate chip
cookies. People were after the fruit roll-ups, the gummies. . . there was a fruit
tape thing: that was the kind of stuff kids were going for. I remember being
kind of upset with my parents. It wasn't even that I wanted to really eat the
junk food as much as I wanted to participate in the fun social exchange in the
lunchroom. I felt very left out.

My parents packed lunch for my sister, too, but she went through a very
picky phase. For a while she would only eat noodles, so for lunch they'd make
a noodle sandwich. That went on for a least a year.

I'm a parent now. My son is young but I'll definitely pack his lunch when the
time comes. I'm not giving him lots of junk food but I might give him a little
treat from time to time.

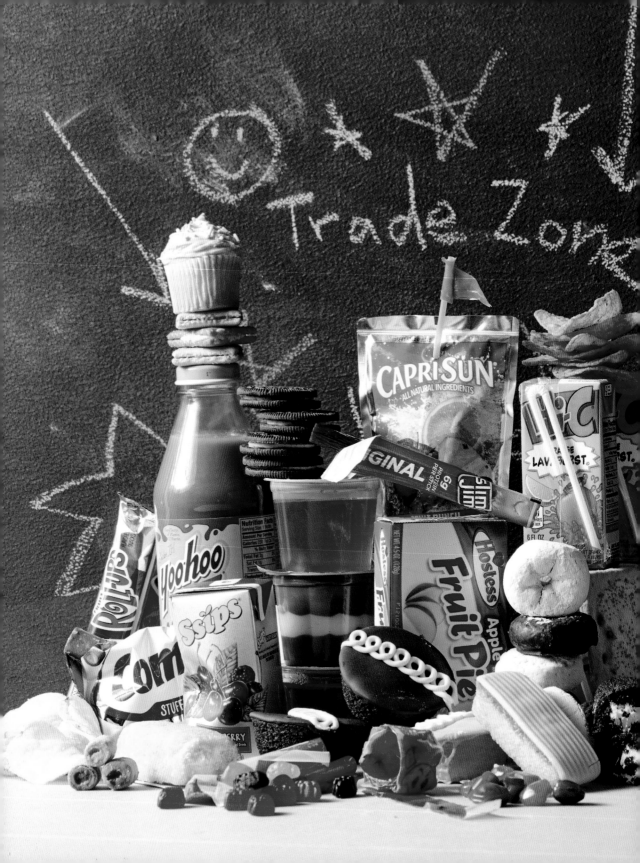

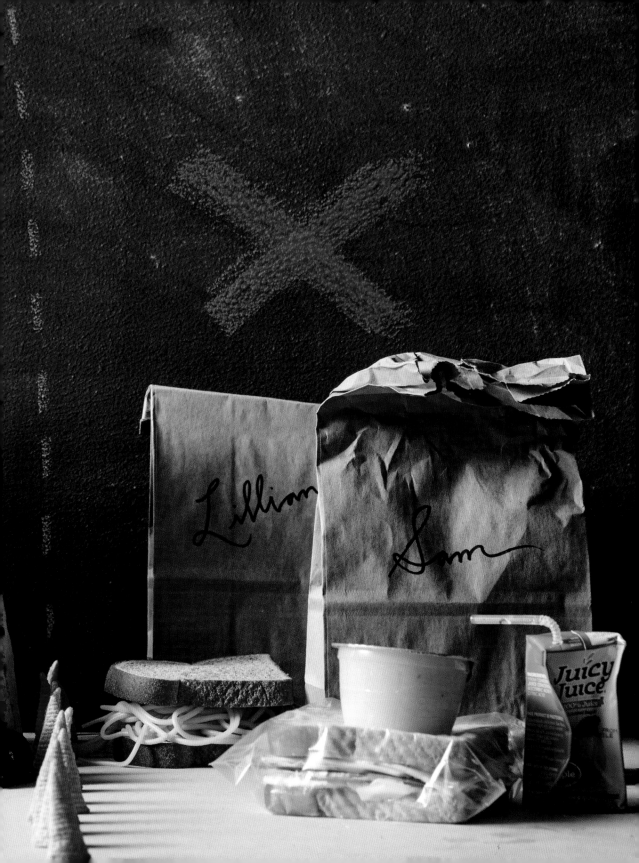

MOM'S ASSEMBLY LINE

GAIL SIMMONS

Culinary Expert, Food Writer, Judge on BRAVO's
Emmy-Winning Series *Top Chef* | Toronto, Canada, 1976

MY ELEMENTARY SCHOOL WAS ABOUT A BLOCK AND A HALF FROM MY
house, so I walked or rode my bike to school every single day. I went by
myself or with my older brothers. Everyone walked, no one thought twice
about it. You'd go out your door and join every other kid in the neighbor-
hood streaming to school. I didn't grow up in the suburbs; it was a very urban
experience. We lived ten minutes from downtown, right on the subway line,
but the neighborhood we lived in was this really amazing residential enclave.

In those days at my school, you could go home for lunch or you could stay
at school. You basically had an hour—from 12 to 1 p.m.—for lunch and recess,
but it was up to you to decide how to use your time. I would say 60 to 70
percent of the kids stayed at school and the rest would go home, or to a
friend's house, for lunch.

I distinctly remember trading off. A couple days a week, my mom would
make arrangements for a friend to come home with me for lunch or I would
go to a friend's house. I enjoyed that, but the bigger treat was actually to
stay at school. I felt like a big kid, packing my lunch and bringing my lunch
box. I liked being with all my friends, trading lunches, and playing.

I remember my mother making lunches. Every night after dinner, she and
my father would clean the dishes and then she would make the next day's
lunches for me, my two brothers, and my father. It was like an assembly line.
My dad was a chemical engineer and his office was in a very industrial part
of Toronto, with nowhere to get food. So my mom packed him a lunch, too.

My father has always been an incredibly disciplined eater. He became
vegan at seventy-five, but he's always been incredibly fit and disciplined. His
breakfast was laid out the night before, because he woke up and left at 6
o'clock in the morning every day. I never saw him in the morning.

"She never cut the crusts off, though. She was not having that business."

My mom would make more or less the same sandwich for all of us. My dad got triple-deckers often and my brothers and I got the single sandwich. It was pretty standard: a lot of turkey, PB&J, peanut butter and banana, whole wheat bread. She never cut the crusts off, though. She was not having that business.

My dad would always get two pieces of fruit, we'd get one. I also remember the Decadent cookie, which was a big deal in my youth. It's a dry, crispy chocolate-chip cookie, with super-dark chocolate chips. I can't explain, but it has a very distinct flavor. When you taste a Decadent cookie, that's that. If I was lucky there were two Decadents in my lunch.

On the days when I went home for lunch, I'd usually have something warm like leftovers from dinner or pasta. Or, there was also this very Canadian thing called Party Sandwiches. The Party Sandwich is a very distinct thing to Toronto and Montreal, specifically and oddly in the Jewish community and the Jewish delis. They're sort of like an English tea sandwich but they are not precious. These were hearty with tuna, egg, cream cheese, and smoked salmon. Some are rolled up like sushi and others made with a long loaf of bread sliced lengthwise and layered with filling. They're awesome.

My mother was a really good cook, so we didn't get a lot of the sort of processed things that many of my friends got. She ran a cooking school and she wrote a column for *The Globe and Mail* in Toronto, which is Canada's biggest paper. A lot of friends didn't like inviting me over for lunch as their parents were worried that I wanted something fancy. But really all I wanted was the stuff that they got at their houses. There was no greater pleasure than when I was allowed to go over to friends' houses for lunch and get hot dogs or Alphagetti and Zoodles.

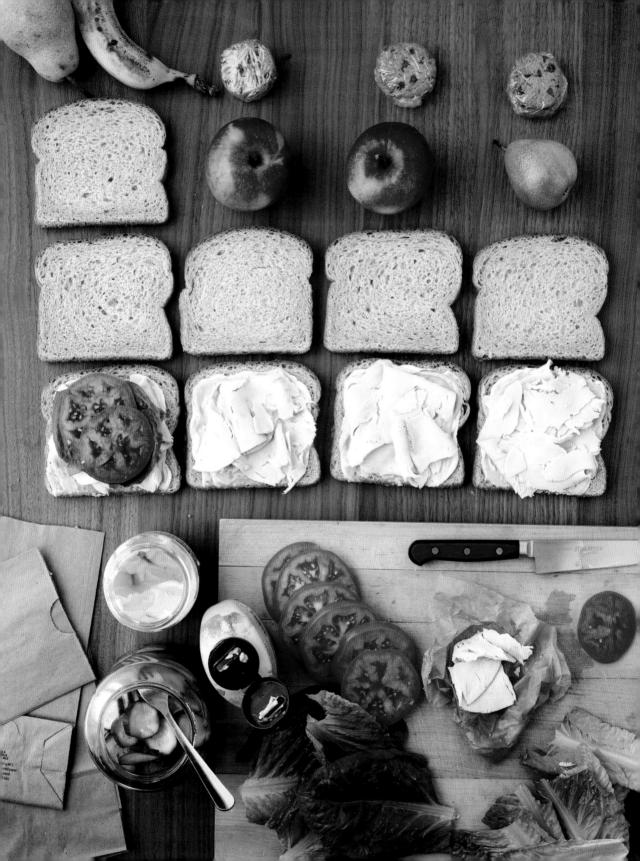

HOMEROOM GRANDPA

KATIE LEE

Author and Cohost of Food Network's *The Kitchen*
Milton, West Virginia, 1981

―――――――――

MY MOM WAS INTO HEALTH FOOD BEFORE THERE WERE QUALITY health food products on the market. If she packed my lunch it was a bit disappointing. She'd make PB&Js with whole wheat bread that sucked every bit of moisture out of your mouth, gritty all-natural peanut butter, and no-sugar-added jelly. Instead of a fruit roll-up like my friends had, I got dark-brown fruit leather rectangles that tasted more like leather than fruit.

I much preferred getting lunch from our school cafeteria. To this day I still really like cafeterias. I think mainly I like getting that tray and having the little compartments.

Thanksgiving was my favorite. I love the perfectly scooped mashed potatoes and the hot buttered roll. I can remember the exact position of everything on the tray.

They let you bring a parent to school for the Thanksgiving meal. My mom and dad both worked and couldn't come but my grandpa was retired, so he would always come. He drove me to school every day and did a lot for me as a kid. Instead of a homeroom "mom" my class had a homeroom grandpa. He and I were best friends. Some of my nicest memories of being a kid were having that little cafeteria Thanksgiving with my grandpa.

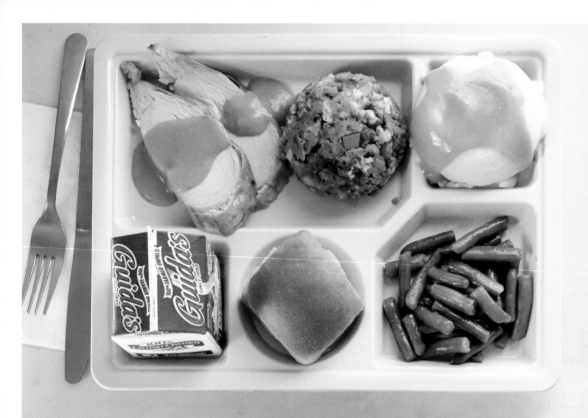
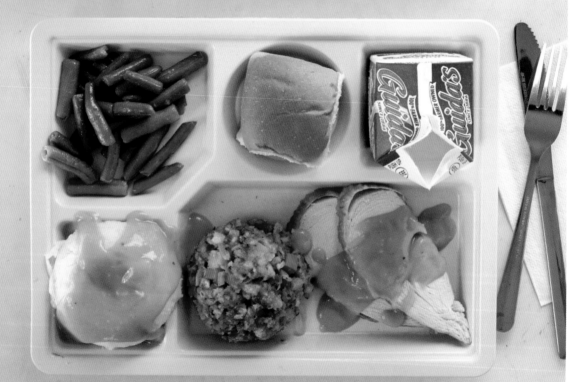

GRANDMA'S TEA AND BISCUITS

ALFRED MOSLEY

Unemployed and Homeless at Time of Interview
Mobile, Alabama, 1955

———————

I WAS BORN IN ALABAMA. MY GRANDMOTHER MADE MY LUNCH. SHE'D never give me bread. She gave me biscuits with PB&J or baloney. One time the guys saw me with my biscuits and they started laughing. After that I used to hide and be by myself at another tree to eat. I felt a little bad but not too bad 'cause it was good. When I was little, I would drink more tea than soda or juice. My grandmother picked the leaves by the side of the road and made hot and cold tea with them. After the mayonnaise run out, she would clean the jar and I would take my tea to school in that.

My brother, may he rest in peace, used to get me from school. We would take the back roads, and the dogs used to come out and chase us. When I was eight, my uncle asked me and my brother if we wanted to come to New York City. We were like, yeah! A couple of country boys; of course we wanted to come—it's New York City!

MORTIFYING FIRST DAY

CHINAE ALEXANDER

Entrepreneur, Lifestyle Personality, Writer, Speaker, and Wellness Expert
San Antonio and McAllen, Texas, 1985

MY MOM PACKED MY LUNCH AND SHE WAS KIND OF A HEALTH NUT. SHE
was a woman of the 90s, though, so her version of healthy revolved around
a low-fat or fat-free diet. We ate a lot of packaged or processed foods that
were considered "healthy" at the time that we now know aren't necessarily
great for you. I wasn't ever allowed to have peanut butter and jelly, because
peanut butter was fattening. But I did get sugar-free Jell-O.

We moved a lot, so the social component of the lunchroom was a big deal
to me. I used to hate that feeling of walking into the lunchroom for the first
time and not knowing where to sit. Each time I moved, the new lunchroom
would be a big culture shock. Even though I hated it so much, moving around
and having to be the "new kid" again and again made me unafraid of change
in my adult life.

My first day of fourth grade was at a new school. I was nervous about
making friends. That day, I opened my lunch box and smelled the *worst* smell.
It was an egg salad sandwich! Social suicide! I couldn't eat an egg salad
sandwich in front of these kids who didn't know me or I'd be known as the
girl who smelled like farts forever. I snapped my lunch box closed and ran
to a bathroom stall to eat it alone. When I got home I yelled at my mom to
never pack that again.

In junior high I moved to one of the richest neighborhoods in Dallas. None
of the moms worked, so they would just come and help out in the cafeteria,
which I found perplexing at first. I wasn't used to seeing white ladies with
blowouts behind the serving line. They didn't cook any of the food there; it
came from local restaurants and was really healthy and good.

After Dallas, we moved back to the border town of McAllen, and I went to
high school in one of the poorest zip codes in the country. Most kids got free
lunch. It was awful, but everyone ate it, because everyone was really poor.

For a lot of kids, school was the only place they were getting meals. I remember people wrapping up their food, and putting it in their backpack, because they were taking it home.

In the wealthy Dallas community, kids generally ate really well. In McAllen, lunch was greasy pizza, with a side of corn, or hot Cheetos they dumped melted cheese all over. Half the kids had signs of being prediabetic. That juxtaposition made me think more about social issues. It made me more compassionate to people. Moving so much helped me to understand that not everyone has a lot, and also that if you have a lot, you're not necessarily happy.

Being the new kid so much gave me a lot of empathy. I'm always looking for that person who is hanging in the back. I've been the kid who has to ask to sit at lunch. So I now try to make it my life's purpose to be the person who says, before someone asks, "Hey, come sit here."

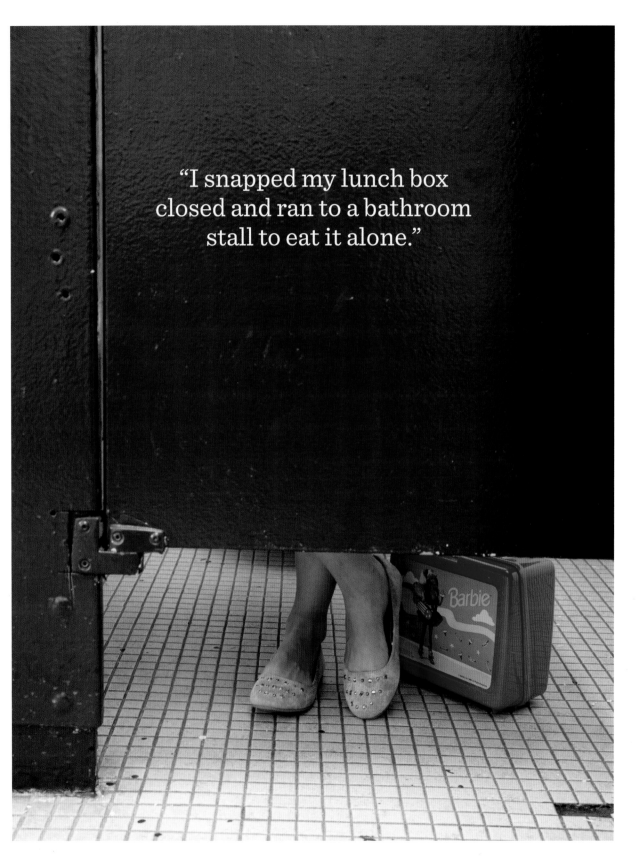

"I snapped my lunch box closed and ran to a bathroom stall to eat it alone."

GROSS-OUT TABLE

ELIZABETH BENNETT

Librarian, Volunteer for Habitat for Humanity,
and Former AmeriCorps Member
Red Bank, Tennessee, 1979

MY ELEMENTARY SCHOOL CAFETERIA WAS NESTLED IN THE BASEMENT
and was really dark. I think it was built during the Cold War and had that
kind of mentality. When you came down the stairs you saw rows of tables
with fixed seats. Each table had its own personality.

I felt at home at the Gross-Out Table, where kids were known for creat-
ing disgusting food challenges. My sister and I were obsessed with Native
American culture, and our parents indulged us. We read books like *Stalking
the Wild Asparagus* by Euell Gibbons and would then act things out—hunting
with bows and arrows in our backyard or digging up plants to eat. We'd
dig up wild onions and daffodils and cook strange things that we'd bring to
school and try to share with the kids. The only ones who would humor it were
the kids at the Gross-Out Table.

Gross-Out Table food challenges would involve mixing cafeteria food with
foods from home and then daring each other to eat it. Ranch dressing mixed
with applesauce & chocolate sauce poured over pizza. Wildflowers dug up
from home on top of a hamburger. The boys were grosser than the girls
because they'd involve bugs, which I would never eat. They'd put worms and
bugs in stuff but I'd be out at that point.

The funny thing is that every single one of those kids from the Gross-Out
Table went on to careers as natural scientists or anthropologists. We all
became world travelers and social activists. I'm not sure if it was the exper-
imentation or the conversation but there was something that took place at
that lunchroom table during those formative years that put us all on nontra-
ditional paths.

My high school cafeteria was an amazing place because of our amazing
lunch ladies. One of the ladies would make homemade yeast rolls every

day instead of serving the frozen rolls the school system provided, because she thought us kids deserved something baked with love. Sophomore year, when I was I having an especially bad week, she noticed my pain, and pulled me into the kitchen. She taught me to knead and work the dough. I literally kneaded out my feelings while she shared with me both baking and life knowledge. She was not necessarily the person that was the most successful in life but she was very successful in ways that our society doesn't value. Her small lessons have really stuck with me.

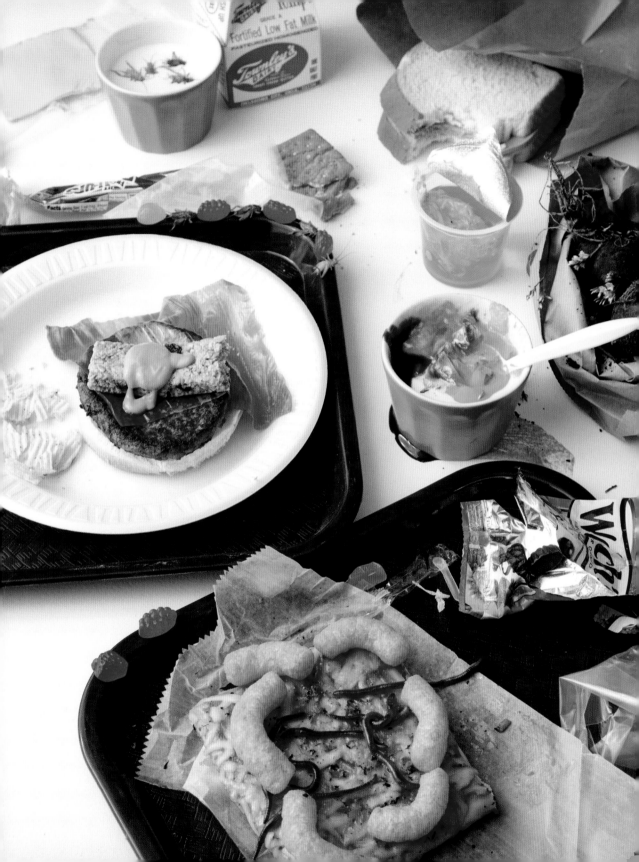

ALCOHOLIC MOM, INDEPENDENT KID

CATHERINE CAMPION

Actress | Minneapolis, Minnesota, 1972

MY MOM HAS BEEN THIRTY YEARS SOBER BUT SHE WAS AN ACTIVE alcoholic when I was growing up. I was the youngest of five siblings, so there was a lot of self-parenting or sibling parenting going on.

I remember being alone a lot of my childhood. I mean, it was a big crazy household but my mom was working full-time as a real estate agent, my dad was working full-time as a banker, and I was the baby, so by second grade I was kind of on my own.

I went to school across the alley from my house. From age five or six I'd walk myself to school, and walk back and forth for lunch. I don't remember there being a lot of rules. For lunch I'd make mac and cheese from a box, or fix a sandwich or pour a bowl of cereal. Even in second grade if I wanted a candy bar for lunch, or to open a beer, no one would stop me. We were allowed to drink when we were kids. If I asked my mom she'd say, "Oh, you had a hard day, sure, you can have a beer."

I was always excited if my mom happened to be home when I came back for lunch. If her work schedule allowed she'd make one of my favorites—Shit on a Shingle, Egg in a Nest, or a piece of toast with a can of baked beans over it. I liked wet food, things swimming in sauce. Shit on a Shingle was probably my all-time favorite lunch. Kids from school were shocked when she said the name. She'd use thinly sliced packaged roast beef (the kind with an iridescent sheen), cooked with gray gravy into a meaty slop and served over toasted white bread. I loved it.

I was five the first time I got drunk, at a family party. I drank a whole bottle of Cold Duck, which is like Manischewitz or weak bum wine. I thought it was kid-wine, but then again I snuck it, so some part of me must have known I wasn't supposed to drink it. I thought my family didn't know but I found out later they knew the whole time I was drunk. I felt out of my bunk bed.

When I brought my lunch to school, the kids in my little provincial Catholic grade school were always appalled. I'd often have paté sandwich or some other meaty

weird sandwich, or Crepes Suzette because my sister went to Paris and came back with a crepe-maker. Once I had a whole Cornish game hen in my lunch and my friends were like "Gross you have like a whole dead chicken in your lunch!" That one was hard to eat; I didn't really have a plate or utensils. I didn't care though, I was *kind of* a cool kid, but more like kind-of-a-weird-on-purpose-kid, and I was proud of it. I was like, "Yeah, I'm the kid who eats a bird at lunch, whatever!" I liked my weird lunches. It wasn't like I was opening it up and getting a surprise, it was things I'd always pack myself, or my mom would help me pack. I loved to experiment with stuff.

Our mom raised us more like a buddy than a mom. Some of my siblings have issues with that but I say to them, who are we as adults? We turned out OK and we turned out to be the women we are because of the way she raised us. I'm forty-six and with my first (and hopefully last) life partner now. Before him, men seemed like kind of an annoyance, useful for some things but not necessary. It's been the same for my sisters, they'd say, "We can't even have successful partnerships with men because we were raised to not need men for anything, and they need to be needed." But that's a big aspect of growing up with an alcoholic parent, to not need anyone for anything. But it was a big party! We drank with Mom, we got drunk with Mom, we could travel on our own, and we could have boyfriends stay over. I wasn't even doing anything that bad: I was pretty much a good Catholic school kid but I had a lot of freedom.

When I was growing up I don't think I even knew that being drunk was a problem for an adult—my mom was drunk, my sisters were sometimes drunk. Since I was the baby I was also shielded from a lot of things. I do remember there was one time my mom threw up all over the car. The car was parked in the backyard at a weird angle and all the car doors were open and my siblings had to clean it. I was the youngest so I didn't have to help but I remember thinking that this wasn't right, other kids didn't have to clean up their mom's vomit.

My dad wasn't a real warm affectionate guy, he was more the 1950s stereotypical guy who provided the money and that was it. My parents split a long time ago but they raised us together until I was ten. He wasn't a bad guy but was just neutral, didn't really discipline us or give much affection.

Right after my parents split and my mom was still a drunk we were drifters. We ended up living in a place called The Driftwood Apartments, which my mom thought was a perfect name for us. We were renting from a woman who was a drug addict, and possibly a prostitute. She lived with her three kids and we rented the upstairs that had three bedrooms. I

was ten or eleven years old, and I let one of the boys from downstairs have a beer with me at lunch. We had one beer each. I knew it was kind of cool to let him have one. His mom would do coke, weed, and alcohol in front of us so she was kind of a "cool" mom, but the kids weren't allowed to do any of that. We did get kind of drunk from our one beer, and apparently he had terrible diarrhea the next day. After that, there was a big hullabaloo from this woman directed at my mom about how I was corrupting her kids. I remember thinking it was ridiculous—you're basically a crack whore and my mom's a real estate agent who happens to drink, what's the big deal?

I remember that specific beer, but I didn't usually drink beer with lunch when I was kid. I just knew that I could if I wanted to. When I was twelve, I'd come home after school and ask my friends if they wanted to share a beer with me. They'd be shocked and say, what if your mom counts them? I'd shrug and say she's the one who buys them for us if we want.

GROWING UP IN THE CIRCUS

PAUL BINDER

Founder of the Big Apple Circus | Brooklyn, New York, 1942

KATHERINE BINDER,

PAUL'S DAUGHTER

Event Coordinator, Former Performer at Big Apple Circus
Toured Year-Round with the Circus, 1985

PAUL: ABOUT EIGHT YEARS AGO, A CHILDHOOD CLASSMATE OF MINE AND I went back to visit PS 206 in Brooklyn, our old elementary school. The principal let us stop in for memory's sake. When I stepped into the lunchroom I experienced one of the strongest sense memories I've ever had. It smelled *exactly* the same as it did sixty-five years ago. It wasn't an unpleasant smell, just completely familiar. I could picture kids unwrapping their ham and cheese on rye.

My daughter had a very different childhood. I founded the Big Apple Circus in 1977. When we were in the circus we were traveling all the time. As a family we lived in a large trailer and meals were served in the cookhouse. The cookhouse was a 48-to 52-foot-long semi-trailer, outfitted with a full chef's line and a walk-in freezer. There was a hydraulic system—the whole side of the trailer would go up and become a canopy, then a floor would come down and be set on portable jacks. Inside were six tables with about six folding chairs each that all traveled in one unit. They were feeding as many as one hundred meals at a sitting so it was staggered. They had a soft drink machine, milk machine, coffee dispenser, and even a sink with soap so you could wash your hands before eating. For food there was always a salad bar, a pasta dish, a choice of sandwiches, grilled cheese on different bread types, cold cuts—and usually two to three other choices. I think in later years they even had a vegetarian option.

Most of the artists ate at home as their trailers had little kitchens, but all the crew and staff would eat at the cookhouse. Our family ate most of our meals there. We would sometimes have family meals in our trailer, but even on those

occasions we'd bring the food back from the cookhouse. There wasn't a lot of time for food prep in those days. Their mother was our horse trainer so morning to night she was busy with the horses.

We also had a semi-trailer that was outfitted as a schoolhouse, called the One Ring Schoolhouse. It was a New York State charter school, operated by an organization called On-Location Education, which mainly taught kids working on movie sets. The enrollment size depended on the year as it was for the kids of performers, staff, and crew members. It was quite extraordinary, the job they did.

My son and daughter grew up in the circus. They were both performers. Katherine worked hard and was a wonderful performer. She graduated cum laude from Barnard, and Max, my son, went to Harvard. So they did all right!

KATHERINE: THE COOKHOUSE WAS MEANT FOR CREW PEOPLE. THE performers had trailers and RVs with kitchens so they didn't eat there. But because we were kids and because we were my dad's kids we were allowed to eat there. Every day was different because show times varied. So we'd eat with different people depending on the day.

My least favorite meal was the Sloppy Joes; I'd skip that one. Sometimes they'd do something cool with local ingredients like a fruit salad with good summer fruit available in the town we were in. I also remember I used to fill a paper coffee cup with pasta salad for lunch a lot.

My mom didn't cook at home; we really relied on the cookhouse. Mom cooked once a year, and that was Christmas dinner. She could cook, her Christmas dinner was delicious, but it was a demanding lifestyle so that's all she had time for. Now that I'm an adult and have kids I sometimes think my parents had it so good. If we were hungry, they just sent us to the cookhouse.

Our school day was very concentrated, from 9 a.m. to 12 p.m. If we had morning shows or something we'd come back and make up the hours we missed, but there wasn't a scheduled lunch period with our classmates like other schools would have. We'd eat with colleagues we worked with on the show or sometimes other kids or family.

I went to the One Ring Schoolhouse my entire school career, starting from pre-K all the way to senior year of high school. I was the first one to do that because we were the only ones to be there consistently every year because my

dad started the show. Most of the kids who were going to school were kids of crew or guest artists and the class changed every year. The year I graduated I was the only one in my class.

I constantly got interviewed as a kid and often asked if I missed going to regular school and having things like prom. I didn't. I got to perform, and I only had to go to school three hours a day—so I could live without prom. I knew how other kids lived from seeing it on TV. Also on winter breaks we'd sometimes be off and my parents would enroll us in local elementary schools for two months at a time. We were pretty on par with our education so we were well equipped. The teachers and other kids were very friendly and accommodating. We were always interesting to people because of our lifestyle.

GIANT CLASSROOM STEAMER

JANE HSU

Retired Physician | Taipei, Taiwan, 1949

WE ALL HAD ALUMINUM LUNCH BOXES. MOST OF THEM WERE OVAL BUT some rectangular. I had a small one; most kids' were thicker than mine. My mother would put the previous day's leftovers in it. I'd have rice, vegetables, and some sort of meat. She'd pack it and tie it with a thin rope, which we'd save, and use again each day. The rope would keep the box closed and also secure your wooden nametag. We all had wooden tags with our names written with Chinese brush and ink.

When you got to school, there would be two huge bamboo and wood baskets that would fit forty to fifty lunch boxes. Everyone placed his or her lunch there. Before lunch, two students would have the job of bringing the baskets to the school kitchen where they had a big steamer to warm everyone's lunches. Sometimes by accident the lid would open on your lunch box during that process and you wouldn't have lunch that day. Kids would beg food from friends when that happened.

Brown Egg was everyone's favorite. It was hard-boiled egg slow cooked in soy sauce. There was one girl in my class whose lunches we always envied. Her mother was a teacher and she went back home and cooked lunch every day. She delivered a fresh lunch box to her daughter at lunchtime. The rest of us just had one layer of tightly packed food. This girl had three layers—nothing packed. The first layer was rice, second meat and vegetables, and the top fresh fruit. She ate the whole thing every day and enjoyed it very much.

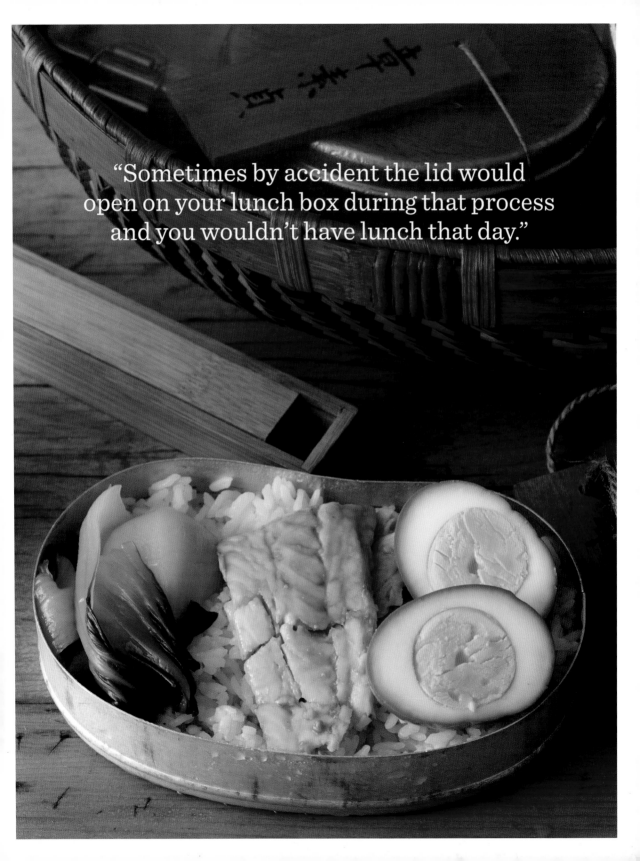

"Sometimes by accident the lid would open on your lunch box during that process and you wouldn't have lunch that day."

NIGERIAN PRIVATE SCHOOL

YEWANDE KOMOLAFE

Chef, Recipe Developer, and Food Stylist
Lagos, Nigeria, 1981

———————————

THE SCHOOLS I WENT TO ALWAYS PROVIDED LUNCH. I DON'T REMEMBER having to pay for it, but it was private school, so probably just part of our tuition. In Nigeria, most of our meats are braised and stewed for a really long time in tomato, pepper, and onion-based sauces. School lunches were either rice and stew or beans cooked in the same sauce, with some fried plantains on the side. I also remember a lot of yams. The food would be similar to meals we would have at home, but much simpler versions. I remember the stew was always really flavorful and sort of spicy. I think in general the food in Nigeria is spicy, even for kids. Maybe it starts when we're little and is just what we are used to. I still like spicy foods.

In my childhood I remember there was a plan for everything, at school and at home. On Monday, we got this and on Tuesday, we got that. We had a menu even at home. That was how my mom ran the house. I remember Tuesdays were always beans and plantains. I think that sense of order was very much a part of my upbringing. I didn't really have to do much planning or thinking. I got picked up for school and then I went to school and came back home. It was very structured.

I don't think my classmates or I really thought much about the food. I liked it, especially the white rice and stew day, but I also don't remember there was ever any choice. I don't remember anyone not eating because they didn't like it or didn't want it. It was more like it was there and that was our next activity. We were supposed to eat and we ate.

I LICKED IT, SO IT'S MINE

ANNA AMMARI

Architect | Amman, Jordan, 1973

WHEN I WAS A KID AT SCHOOL, EVERYONE ATE PRETTY MUCH THE same thing—a *labneh* sandwich or a *zayt and za'atar* sandwich. I've found this to be pretty universal, even for people twenty or thirty years older than me. *Labneh* is essentially sheep's milk yogurt with all the whey strained out, and then salt added. We never drank milk, but *labneh* and *laban* (yogurt) were daily staples.

Our dairy came from sheep or goats; in the outskirts of the city of Amman you'll still see the Bedouin shepherds leading their sheep through the streets. By law you have to stop your car for sheep or you get a ticket. I was often reprimanded by my parents for playing with the shepherds who were only a few years older than me but didn't go to school. I was always very conscious that our cheese and yogurt came from those same shepherd playmates.

My mom was very sick when I was growing up so I usually made my lunch myself in the morning. I'd open up Arabic bread and spread it with *labneh* and sprinkle it with olive oil, or I'd put olive oil and then *za'atar*, which is a blend of dried herbs, such as thyme and mint, with sesame and salt.

The Jordan valley grows a lot of cucumbers and citrus like clementines so I would often add that to my plastic lunch bag as well. We'd knot the bags with a single overhand knot. One of the first things I noticed when I moved to the United States is that people knot bags differently here. I remember thinking it was so strange. When you're young you notice details like that.

Nuns ran our school. Everyone brought lunch; there wasn't a school cafeteria. They had a canteen but it only sold packaged treats, bread, and Angel Kisses, which were cookies with gooey marshmallow stuff on top covered in chocolate. They were so yummy; the nuns made them in-house and we'd buy them every day with pocket money.

Most of us would have around 100 fils to spend daily, which would buy you a bag of chips or sesame bread or an Angel Kiss. If you had 200 fils you

"Then there was one day— a historic moment among my friends—when Rima snapped."

could get a bag of Mr. Chips and bread and make yourself a chip sandwich. The Galaxy chocolate bars were highly coveted at 500 fils, which was half a Jordanian Dinar (JD), an average allowance for the whole week.

My friend Rima always came to school every day with a whole JD, so she could afford daily Galaxy chocolate bars. Rima, Sumaya, Ann, and I had been friends since age three. Rima would buy her Galaxy bar and then the rest of us would all stand around her and watch as she unwrapped it. Jordanians are very hospitable, especially about food. So, of course being a polite girl, each day Rima would buy this big chocolate bar and then hand us each one section. This became our daily routine, all of us sharing Rima's chocolate.

Then there was one day—a historic moment among my friends—when Rima snapped. She unwrapped the Galaxy bar, looked right at us and immediately licked the entire bar all over and declared, "I'm not sharing." We were all floored. We had no idea. We're all in our forties now but to this day we laugh about that story and tease Rima about the day she completely lost it.

In 1994 there was a peace treaty that was signed with the state of Israel. Before that treaty, which was all of my childhood, we didn't get a lot of packaged products that were common in the western world. We got some British imports: Galaxy chocolate, Smarties chocolate, some Nestlé products, but we didn't get a lot of American brands. Hershey kisses were such a delicacy, everyone would smuggle bags back if they travelled. After '94 Jordan became infiltrated with western influence. A McDonald's opened in 1999 and there was a line two blocks long as everyone wanted to try. Now it's a very different place than when I grew up. When I was a kid we didn't have much. The peace treaty of 1994 changed everything.

FAVORITE FRIED CHICKEN TRAY

MAE CULBERSON

Preschool Teacher | Atlanta, Georgia, 1952

———————

I LOVED GETTING SCHOOL LUNCH. WE HAD A LITTLE PUNCH CARD: lunch was twenty-five cents, which was one punch. Some families couldn't afford the school lunch so they would bring baloney sandwiches from home wrapped in newspaper. I'll never forget—one girl would hide hers under her desk to unwrap it every day because she didn't want anyone to see. I used to try to get extra money from my mom and give one of those kids a punch from my card when I could. Those of us with the school lunches would sometimes share some of the good parts.

Fridays were exciting because that was hot dog day. Also, every now and then, you'd get a piece of fried chicken. That was a good day. If you knew someone in the lunchroom you could get a little extra. My mom knew a lot of people so we got the good stuff. Sugar cookies were the number one treat I remember . . . and also the yeast rolls. You wouldn't get that all at once, though, they'd spread it out.

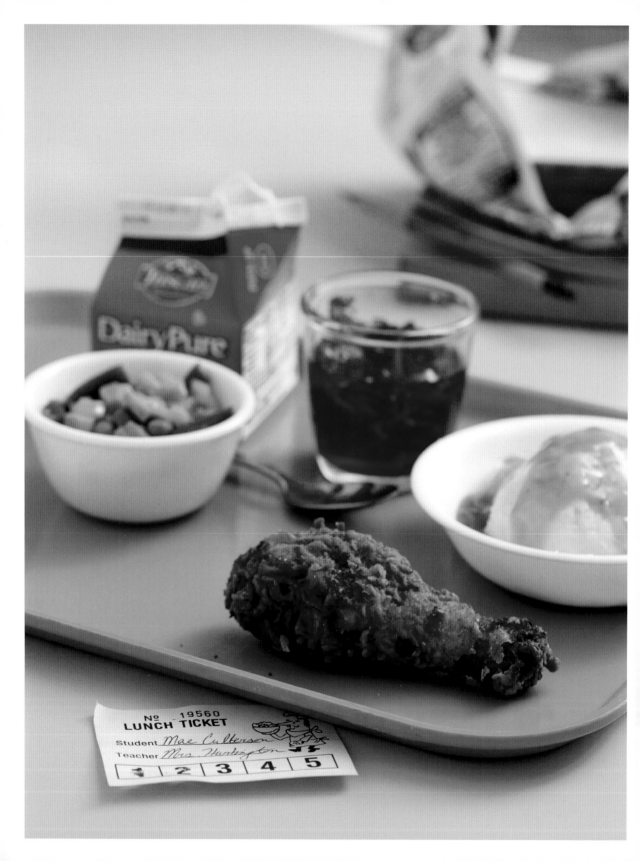

N⁰ 19560
LUNCH TICKET
Student *Mae Culterson*
Teacher *Mrs. Huntington*

| 1 | 2 | 3 | 4 | 5 |

DairyPure

THROWING LIGHTBULBS

TONY PARILLA

"Currently Enjoying Better Living Through Chemistry"
Greenpoint, Brooklyn, New York, 1966

I WAS THE OLDEST OF SIX SO I WAS USED TO LOTS OF PEOPLE. I WENT to Catholic school and we went home for lunch. I'd have peanut butter and jelly, Oreos, and chocolate milk.

We used to climb roofs, especially the roof of the Burger King where Chase Bank is now. There were a lot of Polish refugees in the neighborhood. We used to grab lightbulbs and throw 'em at people. We made a lot of trouble.

"We used to grab lightbulbs and throw
'em at people. We made a lot of trouble."

SHARED RITUAL IN BULGARIA

BISTRA MILOVANSKY

US Immigration and Children's Rights Lawyer
Sofia, Bulgaria, 1960s

SCHOOL LUNCH IN BULGARIA IN THE SEVENTIES WAS A BEAUTIFUL tradition. Each week we would submit our week's choices from the three-course-meal menu, cooked by the school chef. Our first course would be a soup or salad. The main would often be meatballs, mashed potatoes, stuffed peppers, or a stew with beans, potatoes, and peppers. Dessert choices would include crème brûlée, chocolate mousse, and fruit.

The best part was the shared ritual of everything. All the kids brought unique cloth napkins and silverware from home. The napkins were meaningful; mine were my grandmother Anna's. My grandmother had inherited them as part of her dowry from her mother, Zoe, who also lived in our household when I was a kid. They were always freshly washed and ironed. Everyone laid their napkins out as a placemat and also used them to wipe hands and faces. We shared food and stories and laughed together during lunch. It was a practice we all loved.

PERSIAN FEAST WITH TEMPTING AROMAS

FERESHTEH SHOKATI

Former International Education Entrepreneur
Tehran, Iran, 1944

I WENT TO A PRIVATE SCHOOL WITH A TWO-TO-THREE HOUR BREAK between morning and afternoon sessions. Our nanny would come pick me up at noon every day and we'd walk home. My father would come home from work as well and we would all have a full hot lunch. My favorite dish was *ghormeh sabzi* (stew with lamb and greens), and like most Persian stews it would cook for hours. At home, my favorite aromas would fill the air: aromatic parsley, fenugreek, dill, fried onions, dark red sour cherries, different rices, chicken . . .

At break, some families would send nannies or chauffeurs to drop off stacked metal containers full of hot meals from home. The aroma of the food the drivers would bring was so amazing; I wanted my lunch to smell like that! I would plead with my mom to send food but she preferred that I come home. Once in a blue moon, if I cried my eyes out, she would let me have lunch at school.

> "I would plead with my mom to send food but she preferred that I come home."

SEPARATION BETWEEN SCHOOL AND LUNCH

MOURAD LAHLOU

Michelin-Starred San Francisco Chef, Winner of the
Food Network's 2009 Iron Chef America
Marrakesh, Morocco, 1968

FOR ME GROWING UP, THE WORDS "SCHOOL" AND "LUNCH" WERE never put together. There was school, where you go to get an education, and lunch, which you ate at home with your family. The two didn't mix.

My mom and I moved into my grandpa's house when I was a few months old. There were about twelve of us, all family, living together there. Each day, over breakfast, we'd argue about what to have for lunch. Grandma might say, "We don't want to have green peas, let's have okra or fava beans instead." Mom might say, "I don't want to do lamb again, let's change," and then Grandpa would say, "No, I love lamb and it's the season for it. We should have lamb." Sometimes the kids would voice our opinions, too, but it's a discussion mostly for the adults. At some point I realized they'd have this big discussion every day but it didn't really matter—after everyone left for school and work, Grandpa would go to the market and buy whatever he wanted! He'd bring it back and dump it, then they'd make it, and nobody would talk about it anymore.

We went to school at 8 a.m. Exactly at noon, everything in the city shut off. A siren rang and schools, banks, everything, shut down and kids and adults went home for a two-hour break. Some might say that's not productive—you go home, you eat, you nap, you have tea, and then you go back—and in doing so you lose momentum. But I don't agree with that. Food is not just calories to keep going. Eating for human beings is not the same as cars being filled with gasoline to drive; we need more than that. That time you take to go home and eat with the family is a sacred time.

A few members of my family would stay home to make lunch each day. Dough for bread would be mixed early in the morning and dropped off at the bakery to be baked. The bakery knew each family's bread—the shape of it, the tray, the fabric placed between the thin loaves.

Our job as school kids would be to dash to the bakery when school let out to pick up the family bread on our way home. Getting home on time was very important. Lunch would be on the table at 12:30, and no one could start eating until everyone in the family had arrived. If someone were late, we would all sit there and stare at each other in silence until they arrived. When they did show up, Mom or Grandpa would say something like, "Nice of you to join us," and then we'd eat. That person would then hear about it for the next month, or until the next time someone else was late.

Lunch would start with a bunch of room-temperature salads: pureed roasted eggplant, roasted bell peppers, tomato salad, carrot salad with radishes, oranges, cinnamon, and rosewater. The number seven is really sacred so there would always be seven salads on the table waiting for us. Once we finished the salads, a big platter came in. We all ate from the same platter—we didn't have individual plates but would just reach in and share.

The main component of any dish in Morocco is not the protein, that part is small and in the middle, almost hidden by piles of vegetables and a sauce on the outskirts. It's impolite to dig right into the protein first; you have to work your way in from the outside. It's a good way to control what you eat and make sure you have everything in your diet. You'd take the bread and tear it apart, dunk it into the sauce and eat that first. Then you'd move to the vegetables, and then by the end you'd get into the meat. You'd get a small piece and it would be enough. Growing up, we were poor; it would be a kilo of meat (which is about two pounds) to feed twelve people. Moroccans like to cook meat slow and long. This meant the sauce you'd eat with the bread would be infused with flavor and be more important than the meat. After lunch, we'd wash our hands again and have a big platter of fruit. There were no sweet desserts. We'd just have whatever fruit was in season—watermelon, figs, melon.

Lunch was a big ritual, and the main meal of the day. To me, the whole notion of institutionalizing lunch and trusting a major government entity to

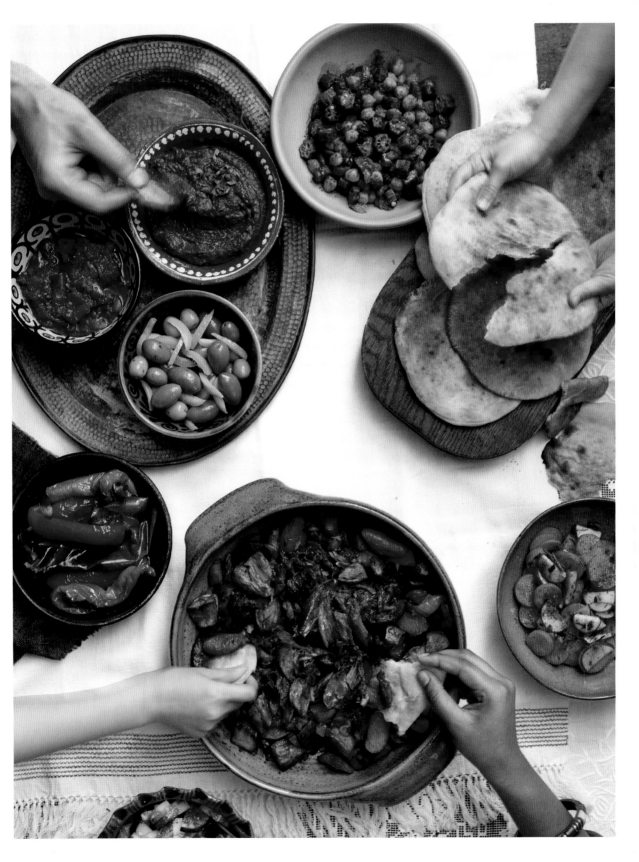

"That time you take to go home and eat with the family is a sacred time."

take care of it takes away the soulfulness of it. The glue that keeps the family together is taken away.

When you talk to somebody and they say, "Oh, my mom makes the best spaghetti" or "My aunt makes the best chicken" you know that's not true. These people are not great chefs, but it tastes great to *you* because you have that special connection to the person making it. Once you institutionalize lunch and make it in a big factory there's no longer that interaction. You're mortgaging your kids' social skills to an entity that doesn't care.

It's really scary when you find out they have $1.49 per kid to make a meal. It becomes about how many calories can you buy for $1.49, but a calorie that is coming from saturated fat is not the same as a calorie coming from an apple. I think the effects are going to be really grave, way down the road over many generations. It's a big price that we are paying in America.

I've lived in America since age seventeen, so I consider this my home. My fiancé and I plan to have children and we don't know what we will do for lunch. It's a big issue I think about.

HUNGRY KID, WORKMAN'S COOLER

MIKHAIL WILLIAMSON

Coach | Kingston, Jamaica, 1992

I HAD ENOUGH TO FEED EVERYONE. MY LUNCH WAS A HUGE LUNCH cooler, like a workman's, as big as a book bag. My mom and dad took turns packing it. They included lots of mini meals. Even in elementary school I played lots of sports and needed to eat a lot. I loved getting linguini and elbows with ground beef meat sauce.

In the early 2000s, the agriculture minister was pushing his "Eat What You Grow" campaign to try to get Jamaicans to grow their own food or buy locally instead of importing. This influenced what went into our lunch boxes. We ate less processed foods and more farm-raised and naturally grown foods like yams, bananas, and plantains.

NIGERIAN FOOD AT HOME, AMERICAN AT SCHOOL

OSAYI ENDOLYN

Writer and Editor | Clovis, California, 1982

WE MOVED FROM THE BAY AREA TO CLOVIS, A SUBURB OF FRESNO, when I started third grade. We lived in a white neighborhood. We were the only black family on the street and I was one of the few black kids at school. There were a handful of Latino and Asian kids as well, but that was about it. My impression was that we all had similar lives, but there were certainly different economic classes. At my school you'd either get Hot Lunch (from the cafeteria) or Cold Lunch (brought from home). I remember Cold Lunch being more the thing to do. I'd have Cold Lunch unless we had run out of time for some reason in the morning.

Many kids had someone at home who was buying food and helping them make lunches. I don't know if Hot Lunch was also associated with qualifying for school lunch support but that might have been a factor.

Even though my father cooked Nigerian food at home for dinner, I don't remember ever bringing that food to school. It was probably just too inconvenient to pack. My mom is black American and grew up in Los Angeles where I'd eventually go to college, and my dad was from Nigeria. I think my dad was always a little surprised that he was raising *American* children. You wouldn't think that would be a shock, but then when it came to school lunch he found the processed foods and meats, fruit roll-ups, and bright-orange cheese puffs to all be a bit absurd. I mean, it is kind of absurd when you think of those ingredients.

My lunch was typical American: lunch-meat sandwiches, a piece of fruit, chips, and maybe baby carrots. My sandwiches were always on wheat bread or very dense-grain, nutty bread. My mom was not out there buying white bread. My parents both worked full time, so from a pretty early age I was

"I always wanted my mom to buy those small-size chip bags, but she never did."

packing my own lunch, or my mom would get it started and I would finish, but I remember that being my responsibility.

I always wanted my mom to buy those small-size chip bags, but she never did. Instead there would be a family-size package of chips (we shopped at Costco), and then we'd portion them out into sandwich bags that we'd take with us in our brown bags. The bags were always the fold-over sandwich bags, never the zip ones. Even as a kid, I always thought they weren't as effective as they could've been.

To drink we had Capri Suns. I *loved* Capri Suns. Oh man, that damn straw—the yellow straw? You couldn't always get it out of the plastic and then jabbing it in was its own challenge. When you put the straw in, it wasn't like you were stabbing it like any other juice box; you had to be careful that you didn't go out the backside. I remember always having my index finger of the other hand protecting the straw from going too far at angle and coming out the back since it was so thin at the top. That was annoying. But I did love Capri Suns.

SECRET JUNK FOOD

BILL SCHAEFFER

Retired Salesman and Transcendental Meditation Teacher
Valley Stream, New York, 1947

I USED TO GET $1.05, WHICH WAS SUPPOSED TO BUY THREE LUNCHES at thirty-five cents each, but that was assuming I could manage money, which I couldn't. There was a really nice ham sandwich on a roll that I would get for twenty-five cents, or sometimes I'd get the roast beef, which was fifty cents. That one was huge and I'd sneak into my bag to steal bites before lunch. Often I'd skip the sandwich altogether and just buy junk food. I was always broke by the end of the week and "borrowing" money from friends. Sometimes I'd borrow money from one friend to pay another back to keep my credit good. Looking back, I'm not sure why I didn't get money for the whole week all at once but I remember $1.05 was the most my brothers and I would get from our dad at one time. Maybe he didn't trust us with more.

DEVILED HAM IN A THREE-ROOM SCHOOL HOUSE

PAULA SCHAEFFER

Director of Enrichment Programs at Pathfinder Village, a Residential
Community for Down Syndrome Children and Adults
Fly Creek, New York, 1945

WHEN I FIRST STARTED SCHOOL IN FLY CREEK WE WERE IN A THREE-
room schoolhouse with seven grades. There were probably thirty of us for
one teacher. We all ate lunch at our desks. The desks were really old with
inkwell spots, lift-up tops, and cast-iron legs—like fancy old sewing machines.
Tommy Eldridge sat behind me and used to move his desk, which made my
seat move. When I'd lean forward to reposition myself, he'd yank one of
my pigtails.

In the wintertime my mother would often pack me a thermos of Campbell's
chicken noodle or tomato soup. Then she'd probably throw in some carrot
sticks, and she might put in an apple depending on the season. Sometimes
I'd get a homemade molasses or sugar cookie if she had them (never a store
bought). Things would all be wrapped in wax paper (which didn't really help
it much), or sometimes butcher paper as my dad was a butcher at the time.

If my mother was out of ingredients and had some leftover ham she wanted
to use up, she'd make this thing called Deviled Ham sandwich. It was so bad
it was like the Devil made it! It was so disgusting: ham ground up fine in a
meat grinder with pickle relish and mayonnaise into meat paste the consis-
tency of over-mayo'd tuna. I hated it.

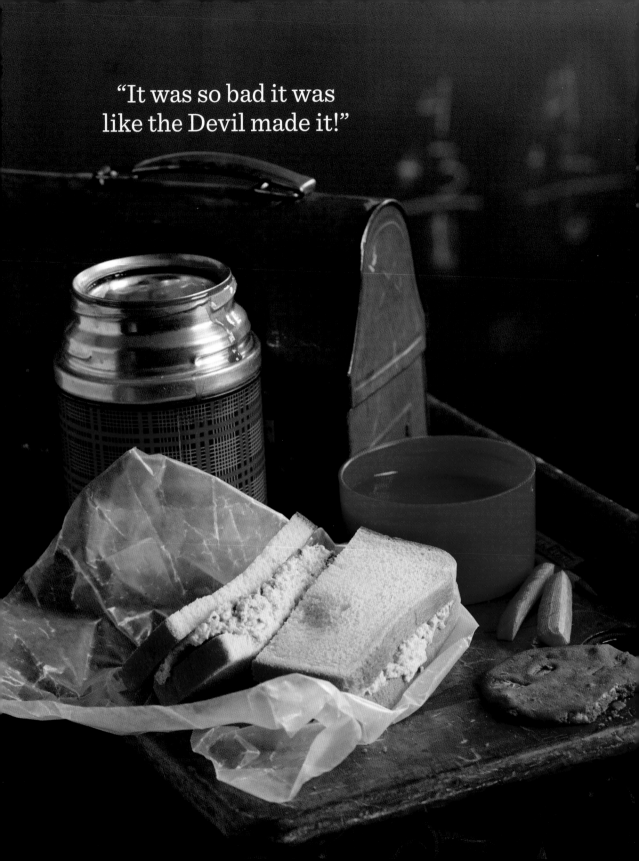

"It was so bad it was like the Devil made it!"

BUDDING FOOD CAREER

JOY BAUER

Host of NBC's *Health + Happiness*, Nutrition and Health Expert
for the *TODAY* Show, and #1 *New York Times* Bestselling Author
Tappan, New York, 1963

WHAT I LOVED MOST ABOUT WHERE I GREW UP WAS THE DIVERSITY; every economic class, religion, and ethnicity was represented. There was even an army base right by my house. I was the oldest of four kids so among the four of us we knew a substantial number of people in the town. Our community was strong; we had carnivals and fairs, spelling bees, barbeques, and get-togethers. School plays and sports were big business. The football and soccer games were packed and spirited. It was an amazing place to grow up.

I wasn't a picky eater; I was never a cut-the-crust-off kind of girl. My lunch was always a thin sandwich on white bread, some form of produce, and a small treat. My mom would slice the sandwich into quarters—oh, how I loved that as it gave me lots of finger food pieces to enjoy.

My treat was usually a small bag with two Oreos or two Chips Ahoy cookies. Sometimes, if I hit the jackpot, my mom would put in a pack of Drake's Coffee Cakes, Ring Dings, Devil Dogs, or Yodels. Haha, times have really changed.

Everyone was very interested in my treat. Even though it was a small portion I always ended up splitting it with my friends. The irony of the future nutritionist having the best treat at the table is pretty darn funny.

Even though I always savored the food, my favorite part of my lunches was getting a note from my mom. She didn't add them every day, only if I had something special going on at school. Later, when I had my own kids, I wrote notes for them, too. So much of what my mom did for me has been carried through with my own three children. I imagine that later when my kids have their own families, they will continue these traditions, as well.

My passion for cooking (aka playing with food) really started in elementary school. Third grade was a turning point for me as that's when I started making messes in my mom's kitchen. I had all of these self-taught adventures

and somehow things magically worked. In fifth grade I made my first real creation, a blueberry muffin that I whipped up by very loosely following a recipe. I was so proud. I remember bringing these muffins to school the next day and presenting them to friends at my table. I even had some set aside for the lunch ladies. It's funny, I remember the lunch ladies said they were going to save them for later so they could really relish them, but in hindsight I think my seatmates might have been giving them secret signals to steer clear. Let's just say there were plenty of leftovers!

That was the beginning of a beautiful relationship with food and cooking. Needless to say, as my kids were growing up we spent a ton of time in the kitchen inventing fun and delicious recipes. I would always include their creations in their lunch bags the next day so they could take pride in them just like I had with my scrumptious blueberry muffins.

"The irony of the future nutritionist having the best treat at the table is kind of funny!"

Dear Joy,
Good luck on your test today, I know you'll do great! ☺
See you at the game tonight!

love, Mom

BROWN BAG, BROWN DAD

LYNELL JINKS
Creative Director

ZELINA JINKS & IZAAC JINKS,
LYNELL'S CHILDREN
Ages 14 and 12 at time of interview, Martinez, California, 2019

LYNELL: I'M A CREATIVE DIRECTOR AT WWE 2K19, A PROFESSIONAL wrestling video game franchise. I started as an artist, and over ten years ago, I moved to being a creative director in more of a manager role.

I definitely didn't get hand-drawn lunch bags as a kid. I'm one of five kids—when I was a kid I was the one always packing the lunches, it was one of my chores. I never really thought about drawing on lunch bags until one day when my younger son was in preschool. He was going on a field trip and needed a disposable lunch bag instead of his usual lunch box. My wife asked me to label it or make a little drawing on it. I did a fun, quick Iron Man drawing and labeled it "Izaac Man."

He came back from school that day all excited—everyone had loved his bag and he wanted more. That's when I started drawing the bags for both kids. It was rare then that I got to scratch that artistic itch at work so I had lost touch with that side of me. When I started doing the bags it was like reconnecting with something I'd forgotten. As a kid, my mom used to bring home reams of paper as a present as she knew how much I loved to draw. I got that feeling back when I started doing the bags.

During that first year I did them every day, which required a lot of dedication. During that honeymoon phase it was awesome, I was getting faster and better with each one. But then I definitely crashed, I was so tired because I was staying up until 1 AM drawing on lunch bags. I asked my kids if it would be ok if I just did them once a week. They said yes, just don't stop! So now they

get the lunch bags every Monday, and on special holidays and occasions. I started putting them up on Instagram, too: @brownbagbrowndad.

ZELINA: WE'VE BEEN GETTING THE BAGS FOR A LONG TIME. MY FAVOR-ite was the Gremlin one. On Mondays everybody comes up to me and asks to see what my dad drew. My science teacher asks me every Monday to show her; once she joked with me that if I didn't show her a bag she would fail me.

We really use them for our lunches, then we bring them back to save them. My bags come back usually ripped and crumpled. Izaac keeps his neater.

For lunch I get chips and fruit, and I like salads with romaine lettuce, sliced carrots, and ranch dressing. It's simple because I don't like anything else—like chicken or cheese—in my salad, it grosses me out. Also, if I eat something too much it just doesn't taste good anymore. For example, my dad was giving me a bagel and cream cheese over and over again and I had to tell him to stop because I got tired of it. So he tries to mix it up.

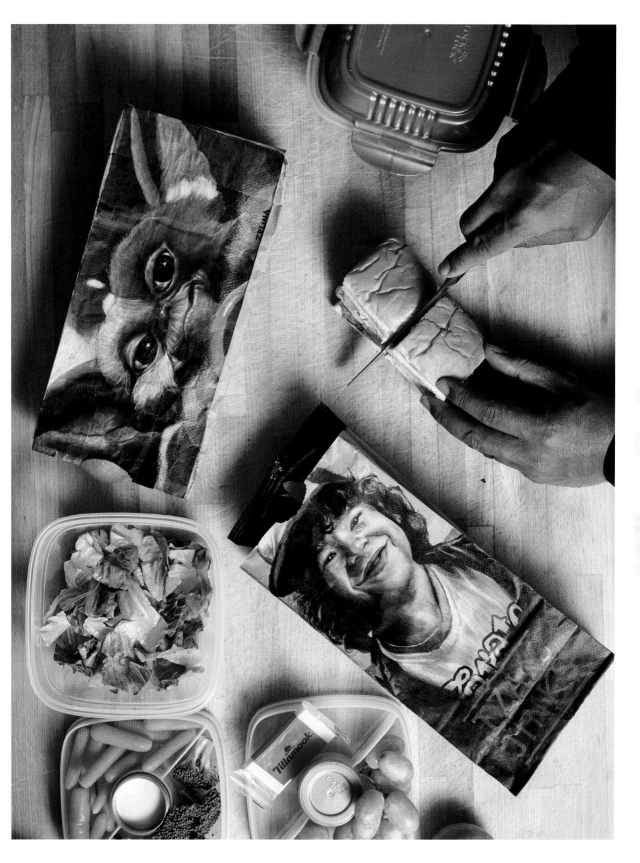

Lynell: "When I started doing the bags it was like reconnecting with something I'd forgotten."

Sometimes if I'm not hungry I won't eat lunch and I'll just go play basketball on the blacktop or walk around with my friends. But most of the time I eat my lunch.

There was only one lunch bag that didn't come back, that was the Raven-Symoné one. Somebody stole it at my elementary school.

IZAAC: MY FAVORITE BAG WAS THE *STRANGER THINGS* ONE, WITH Eleven. For me, it's the same as my sister said—kids are always asking me to see my lunch bags. They ask how he draws it and what kind of pencils he uses. They ask me a lot of questions, and I tell them all the answers. I'm not good at drawing—I draw when I have to, but Zelina really likes drawing and is good at it, so she draws in her free time.

My lunch is like a snack, I'll eat it and play basketball, and then if I'm still hungry I'll get some pizza or something from the cafeteria. We have thirty minutes for lunch and you can use it however you want.

There was one lunch bag that didn't come back for me. It was the Barack Obama one.

My elementary fifth grade teacher saw that bag when I brought it to school. She asked me if she could keep it and I said OK. We later found out that she was friends with Barack Obama's secretary. They had lunch together and she showed the secretary the bag. He took it and gave it to Barack Obama, and then Obama gave my dad a shout-out on Instagram. That was pretty cool.

KID-MADE, SOGGY RAMEN

JAKE HAKANSON

Producer | Portland, Oregon, 1976

MY MOTHER TAUGHT ME AT A YOUNG AGE TO MAKE MY OWN FOOD and leave the house for school because she liked to sleep in. I would take two pieces of bread and put a slice of cheese between them, with absolutely nothing else. Then I would make ramen noodles and pour them into the thermos. By the time it was lunchtime they would be big soggy noodles. I liked eating the ramen but I would never eat the bread at school, I'd just eat the cheese out of it. It didn't taste good because it was just two slices of bread but I figured I was supposed to make a sandwich. I'd also get a quarter for milk money from a little bowl in my mom's room on my way out. In third grade my family qualified for free lunch so I'd get whatever the school cafeteria was making. It was your basic unhealthy school lunch—meat with sauce, canned green beans—but it was a big improvement over my cheese sandwiches.

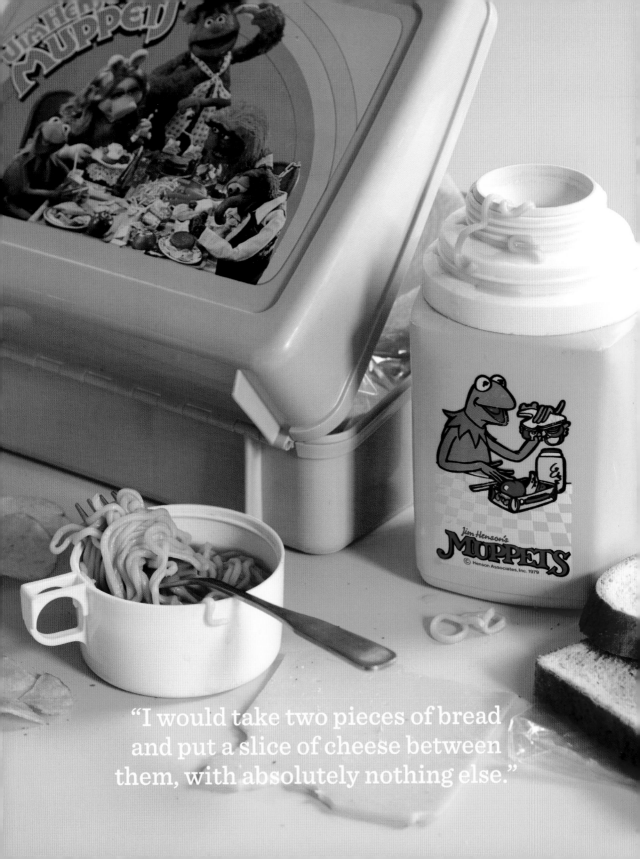

"I would take two pieces of bread and put a slice of cheese between them, with absolutely nothing else."

TV LUNCH WITH CASEY

STEVEN ENGLER

Business Principal, Interior Design Firm
Hopkins, Minnesota, 1952

MINNEAPOLIS HAD SOMETHING UNIQUE IN THE 50S AND 60S: LIVE shows taking place at studios in the area. You'd just turn on your TV and watch them. A favorite with kids was *Lunch with Casey*, which you'd watch midday if you were home sick from school. Casey Jones was a railroad engineer with a sidekick named Roundhouse Rodney. The two of them ran this funny TV show. There was no Internet back then but the local newspapers would always print the weekly menu for the *Lunch with Casey* show. They included every single detail so your mom would make that exact lunch down to the grapes and dessert and then you'd be able to eat along with Casey.

In those days we had a half-dozen metal TV trays that my family would eat and smoke off of. On sick days, my mom would set me up with a metal snack tray in front of the TV for lunch. During the show, Casey would pick up his tuna fish sandwich and say, "Now kids, we're going to have another bite of tuna fish sandwich! And now a carrot stick!" and you'd eat right along with him. Hostess sponsored the show, so you'd also always get a Twinkie or Hostess Cupcake at the end, along with a big glass of milk.

If it were your birthday, your mom would call ahead to get your name added to the Casey Jones birthday song. He'd always sing the birthday song at the end of the program. You'd freak out if you heard your name because Casey Jones was wishing you a happy birthday!

I got started collecting lunch boxes after visiting a quirky friend with a quirky business he calls *Past, Present, and Future*. He's got every kind of thing. I was over there in '84 or so and he was digging out some stuff and pulled out a dome-shaped Roy Rogers lunch box and asked me if I wanted it. I said yes because I *had* that lunch box (I think it was a '57). I took it because it was beautiful and I loved Americana art.

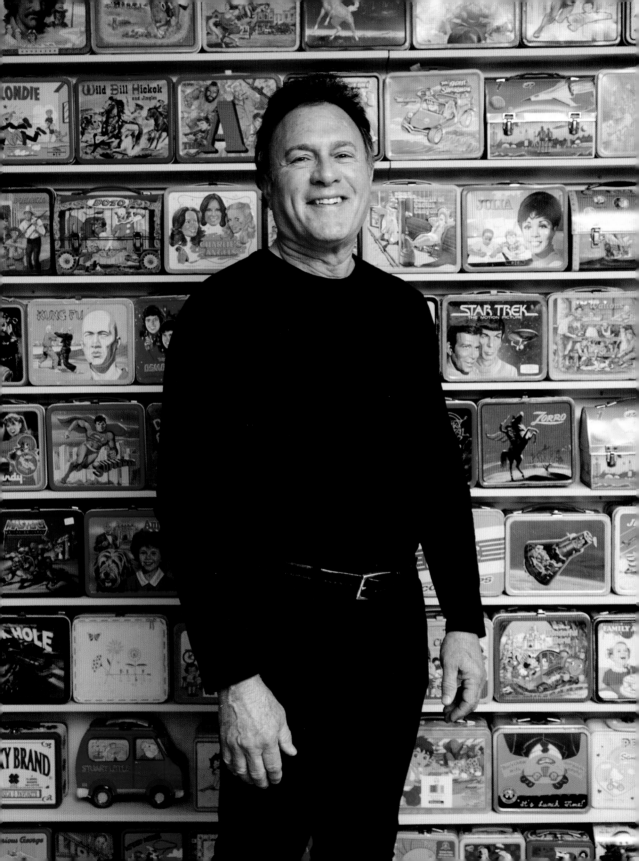

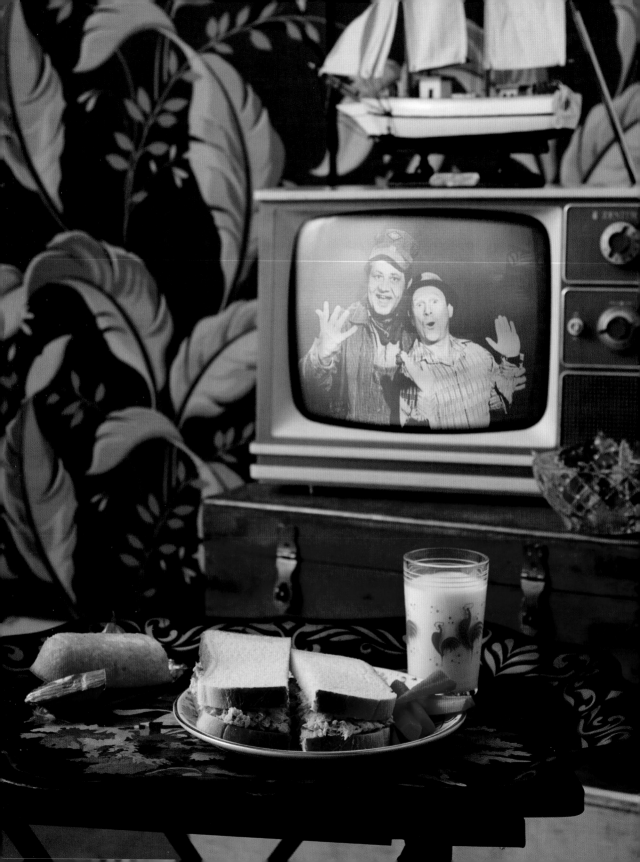

"I've now collected hundreds and hundreds of vintage lunchboxes."

My childhood came at the beginning of children's lunch boxes. The first one was a cowboy-themed lunch box, made by Aladdin in 1950. After cowboys, they started branching out into kids' TV shows and action heroes. There were four hundred or so different lunch boxes made until 1985, when the last metal Rambo lunch box rolled off the supply line.

Moms protesting the danger of metal edges changed the market. In the 60s, they started making lunch boxes out of vinyl over cardboard like those Barbie carrying cases. Most of them disintegrated but I have about thirty of them from that era. Later came plastic.

The first thermoses had glass on the inside and a lot of those broke. Mothers would take those out and put them in the attic to make room for the grapes and chips because there was milk at school.

I've now collected hundreds and hundreds of vintage lunch boxes. I keep many on display shelves in my basement where they are protected from light—which makes them fade. I like the art and the energy. If you stand in front of a wall of lunch boxes you're going to charge up. They're all positive.

SOMALI REFUGEE, ADAPTING TO NEW FOOD

SACIIDO SHAIE

Community Leader, Volunteer, Motivational Speaker, Author
President and Executive Director of Ummah Project
Mogadishu, Somalia, and Minneapolis, Minnesota, 1982

I WAS BORN IN SOMALIA AND ONLY HAD TWO YEARS OF SCHOOL before we fled the country. Back then, there was no lunch at school because it ended at 1 p.m. I ate at home early in the morning before school. My mom always made *anjero*—which is a very thin, soft rolled pancake. Usually it's good to eat with fat or meat but we didn't have a lot of fat. My mom used to add sugar and oil. I hated it.

I remember one day my mom made a whole pan of *anjero*, gave me a couple, and then went to the bathroom. I didn't want to eat it and with my little kid logic, instead of throwing mine out, I threw the whole big plate of them out the window. My mom came back and went to feed my other siblings and saw the empty plate. She turned to me and I was shaking. She looked at me for one second before I ran out the door as fast as I could. She woke up my brothers to go chase me. I ran so hard it took them thirty minutes to catch me! By the time my older brother caught me he was so tired he was about to cry. He started beating me on the spot. I came back home crying, full of sand. When my mom saw me, she didn't know what to do. She didn't have any money to buy more food. She was more sad than angry. She would rather have given me food that I liked to eat. In that moment I realized that and I felt for her. I never forgot that incident.

After school ended, we'd have lunch at home. We'd have pasta or rice with sauce and meat—and a banana. Every Somali meal comes with a banana on the side. You can cut it up and eat it with the meal, or just eat it on the side. It would always be the banana, a little salad, plus a lemon or lime slice on the side.

"Every Somali meal comes with a banana on the side."

I was seven when I came to America as a refugee. They gave us cereal in the morning. I had never seen that before. The milk we had in Somalia was organic. The American milk tasted totally different. They put it on the cereal and told me to eat it. I tried it, but then started throwing up on the spot. Even the American water tasted different; there was a bad after-taste that stayed in your mouth. I used to be so skinny and malnourished when I was little. I would wear layers of clothes to make myself look big. I was always cold.

I have one son and two daughters who have grown up here. When you raise your kids in a country that is not your homeland you have your own customs. Your kids are used to that. Before school started, my kids ate only Somali food at home. I made everything from scratch, we didn't go out to eat. When my daughters started going to school it was difficult for them to eat the school food. Culturally, they were not accustomed to the taste. I saw that my kids didn't like the school food at all, but they didn't want to take food from home because no one else was doing that. They ended up just not eating. My daughter ended up with low iron from skipping lunch. Sometimes I would try to pick her up and bring her home for lunch but that was very difficult because I have to work. What I did was to start buying food from outside so she could learn the taste. I'd get McDonald's and French fries and all of those things to teach her about this new food. My second daughter got it, but it was very difficult with the first one.

Their school has a big population of kids from all over—Somalia, Ethiopia, Mexico—and it should be thinking beyond burgers and fries for lunch. The school is only 18 percent white, but everyone is eating white food. Some cultures don't even eat meat. So if one day the only option is meat, those kids won't eat. It's not healthy or balanced.

BAD BOY OF JERUSALEM
SAMIR "SAMMY" ABED

Bodega Owner
Beit Hanina, Jerusalem, 1965

———————

I WAS A BAD KID, ALWAYS GETTING IN TROUBLE.

I had seven sisters and six brothers. I'm number six. For lunch, we'd get whatever our mom gave us—simple things like pita bread with a little olive oil and *za'atar*, sometimes with tomato or a slice of baloney inside, all wrapped in newspaper. On the days she didn't give us food we'd get money from our father to buy a falafel sandwich and drink at the school canteen. Falafel was the only choice but it was made fresh and you could choose what you wanted on it: lettuce, tomato, onion, jalapeños, hot sauce. I liked it spicy. We would just grab and go and sit to eat in the soccer field on benches.

Sometimes my friend and I would steal other kids' lunches. We'd only rob the rich kids, not the ones like us. Two kids in my class had fathers who worked for the foreign embassies—one German and one French. Their parents shopped at the supermarket on the base, so they had fancy lunches. This one rich selfish guy would tease us with his lunch saying we didn't know what peanut butter was (which we didn't). So we'd rob him to try it. My friend would go up and talk to him and I'd sneak back and take the lunch out of his bag. Peanut butter and white sliced bread tasted really good.

Our teacher knew my friend and I stole lunches. One time he caught us eating a baloney sandwich on white sliced bread. He asked us where we got it and I said "my mom." He laughed. We all knew that kind of food is what the rich kids eat; most of us had pita or country bread. We never admitted to stealing it, but he knew.

One time my teacher beat me with a stick because I beat up another kid. After school that day, I beat up the teacher's son. The next day the teacher told me not to touch his son. I told him not to touch me and I wouldn't touch his son. That worked.

I went to that school until fifth grade, and then I dropped out and started washing dishes in a kitchen with my cousin. A lot of kids dropped out. My mom didn't know for about three or four months. I dropped out and just kept leaving and coming home at the same time as school. Eventually my cousin ratted me out. At first my mom got really mad, but then she said it was my choice. She had a lot of kids so she couldn't really keep track. The rest of my brothers and sisters stayed in school, I was the bad one always getting into trouble. I blame my friend; he was always making me do crazy stuff.

"We'd only rob the rich kids,
not the ones like us."

HOT LUNCH FROM THE MAID

JOBY ABRAGAN

Software Developer | Quezon City, Philippines, 1975

A MAID WOULD BRING ME HOT LUNCH TO SCHOOL EACH DAY. MOST people had maids in the Philippines, not just wealthy people. We didn't have insulated containers to keep food warm, and no one ate cold food, so maids bringing lunch was very common. No one really bought lunch at school. There was a canteen but it only sold pimiento cheese sandwiches and cold drinks.

My lunch would usually be steamed rice and a hot Filipino dish, made that day. Some favorites were beef or pork stews like *Kaldereta* and *Mechado*, or rice noodles (*Pancit Bihon*) or fried chicken. Whenever money was tight I'd get some kind of fish dish, which I didn't really like. Fried milkfish (*Pritong Bangus*) was good as dinner but hard to eat out of a small container because of all the little bones. Whatever the dish, I always picked out the vegetables and left them on the side—I didn't like that part.

I never got a drink and was always jealous of my classmates with thermos containers. I would beg sips from my kindergarten friend every day. She would give me a look each time. When I got older and I had a little bit of money I would buy sweet juice drinks from school canteen. I loved the melon juice, made with shredded cantaloupe bits and sugar.

SIMPLE KOREAN DOSIRAK

HOASUNG LEE

Retired Surgeon
Inchun, Korea, 1939

WE ALL BROUGHT *DOSIRAK*, METAL LUNCH BOXES, TO SCHOOL EVERY
day. The school didn't have a kitchen.

Mainly we had steamed rice, sometimes mixed with barley. Most of the
time we had a separate container of kimchi. Sometimes we got *kongjang*,
fermented black beans, or dried-up minnows prepared with soy sauce and
a little sugar if we had it. It was all in a metal rectangular box: one side rice,
one side the rest. If we were lucky we got fish tempura cut up. We all used
regular metal chopsticks, there weren't special ones for kids. The best treat
some kids would have was a fried egg on top of their lunch, but not everyone
could afford that.

The whole thing was tied up in a cloth to carry to school. In the winter our
lunches would get so cold so we would stack them on the school stove to
warm them up.

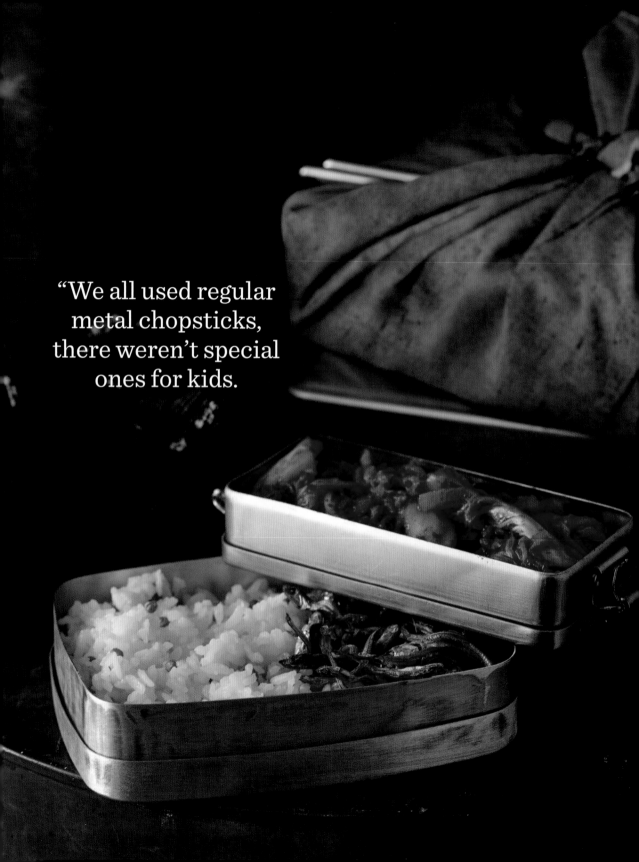

"We all used regular metal chopsticks, there weren't special ones for kids.

GERMANY, DURING AND AFTER WW II

ANNEGRETE BARNUM

Retired Dressmaker | Drelsdorf, Germany, 1934

I GREW UP DURING THE WAR. WE'D GO TO SCHOOL FROM 7 A.M. TILL noon. At ten o'clock, we'd get a piece of Schwartzburg black bread with a little lard spread on it and sugar sprinkled on top. At noontime, when you went home, the big main meal was on the table.

Everyone lived exactly the same way, from the land. We had chickens and pigs and ducks and on our land we grew and canned everything. You didn't go to the store for anything but sugar. My mother was home with seven little girls. All the men were gone at the war so it was just grandfathers, kids, and women.

After lunch we would work in the fields. In the fall we'd do the threshing and cut the grain. A lot of the grain would fall off during that process, so the kids would take baskets and collect rye grains, and mothers would roast and make coffee out of it. We didn't waste anything. We made our own sausage with a hand grinder and intestines. We'd bring them to a smokehouse and pick them up a few months later. We had to schlep water from the pump to the house for every drop we needed for washing and cooking. To drink we'd have two buckets of fresh water, with a ladle we all shared, but everyone was always healthy.

The worst thing I can remember from those days were the potato bugs. Potatoes were a huge mainstay for us. I hate to say it but the Americans came over and they dropped the potato bugs. We were released from school when it got so bad. They took us to the fields and we had tin cans to pick potato bugs into. When your tin can was full you threw them in the fire. The noise of that still gives me chills.

My dad was a shoemaker so he was one of the first to be drafted for the war because they needed someone to fix boots for the soldiers. Three days before the war was over my dad was in Hamburg. An officer brought three of them overalls and told them to change out of their uniforms and go home,

that it was about to all be over. My dad came home and we didn't even know he was in the house. My mom hid him in the attic and told me I couldn't go up there to use my sewing room because of rats. I only learned he was home on the day the British came, when he came out of our house with his hands up. They took him away but he was back in two weeks because he hadn't done anything wrong. I'll never forget that.

It was wonderful when the British came. I was eleven in 1945. The Brits treated us really well. They came every day to the school with the soup wagon. We had one thousand refugees that all came up after the war so the population of our town more than doubled. I went from sharing a bed with my sister to sharing a bed with my sister and Maria, the refugee.

Our school wasn't big enough anymore so we had school in barns. We had goulash and American white bean soup. We all fell in love with that. And they brought little chocolate bars; they would throw it as they drove through town. What a treat that was.

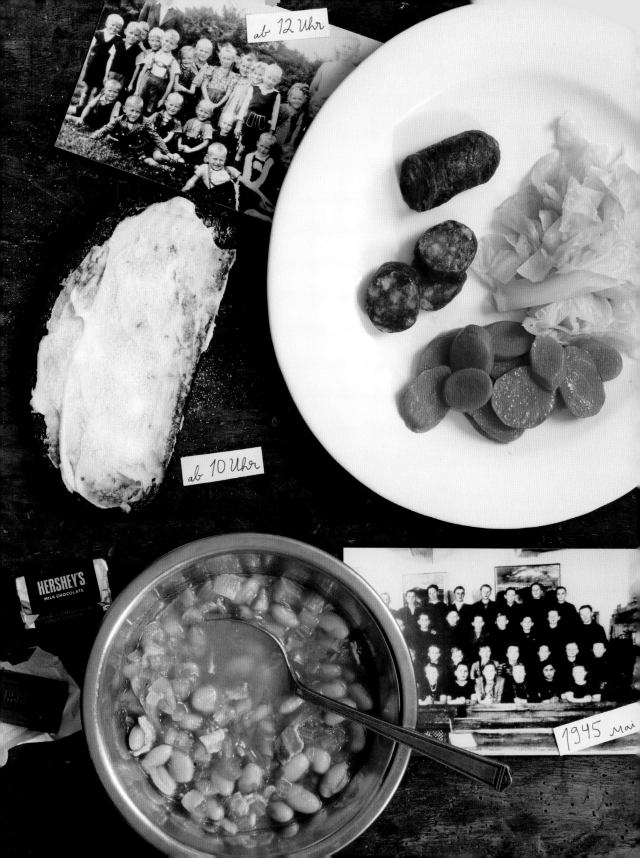

ab 12 Uhr

ab 10 Uhr

HERSHEY'S
MILK CHOCOLATE

1945 Mai

JAPANESE KYUSHOKU

YUMIKO MUNEKYO

Sake Importer | Fukui, Japan, 1985

———————

WHEN I WAS IN PRESCHOOL MY MOM WOULD PACK A BENTO EVERY day. Nowadays everyone talks about organic cooking and food; my mom was ahead of her time thirty years ago. She used to make everything from scratch, even miso paste and *shoyu* (soy sauce). She was all about nutrition. I'd get things like a *tamagoyaki* egg roll, fried chicken made from scratch, and leftover *daikon no nimono*—braised Japanese radish. I'd get five or six kinds of food but it was mostly yellow or brown. When I was a kid I didn't like this. I wasn't proud of my brown bento and often didn't want to show it to other friends who would have cute pink sausages or other artificial colored foods. But now I have two daughters and I'm now the one making brown bento.

I didn't have a bento for elementary school because Japanese public elementary and middle schools all serve government-provided *kyushoku*—school lunch. It's an amazing nationwide program of healthy school meals. There's always soup, an appetizer, a main dish, rice or bread, fruit, dessert, and milk. Compared to American school lunch the quality of Japanese *kyushoku* is off the charts.

My class was divided into groups and each group would take turns being the lunch servers for a week. When it was your turn, you'd wear special white cooking clothes (a jacket and little hat). At the end of the week you'd bring it home and wash it, then bring it back to pass on to the next group.

Kids always loved being the lunch servers. It was fun to scoop the soup and the rice. You felt like you were a chef. Being more involved helped us to consider the food more. You'd have to think about portion size because you had to make sure the food served all thirty kids. We ate in the classroom. During class we'd always be facing front, but for lunch we'd turn the tables and make little groups so we could enjoy our meals and conversation.

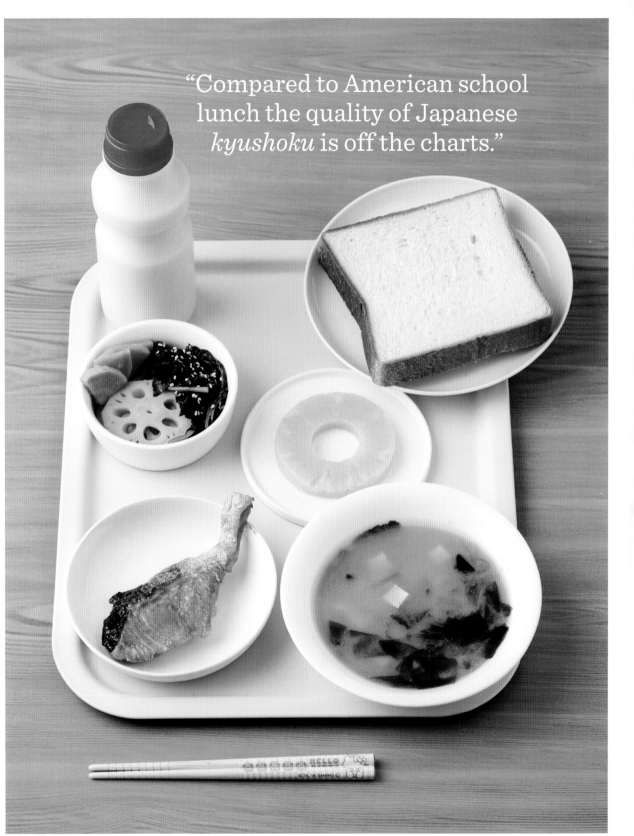

"Compared to American school lunch the quality of Japanese *kyushoku* is off the charts."

A MEAL IS NOT A MEAL WITHOUT BREAD

LAURA MARTINEZ

Tattoo Artist | Sartrouville, France, 1988

———————————

MY PARENTS WERE BOTH WORKING EVERY DAY OF THE WEEK SO I always ate at the canteen at school. From age five to twenty-two I ate at a school canteen, and the food stayed very similar. It was not the best food for sure, but it was not the worst. I'm actually not that complicated about food so I usually loved it, even when other kids would complain.

The public school canteen always served a typical French meal with appetizer, main, cheese, fruit, and bread. The bread was little baguettes the size of your hands. You were only allowed to take one but we were always stealing as many as we could. My strongest childhood lunch memory is all of us trying to fit baguettes into our bags and pockets. We'd keep the stolen extra bread in our bags and eat it throughout the day. On days when the food was bad we would take the cheese or pate and eat it with lots of bread. We ate so much bread.

There was a lot of debate around the meat they served when I was at school. The government-set menu was not providing enough options for Muslim kids. They would serve fish on Friday for Catholics (which no kids liked) but then on other days the main was often pork with no other choice. There were only three white kids in my class when I was in elementary school, so this didn't fit with our largely black and Arab community. We all ate what was provided; no one brought their own food, which meant Muslim kids were often just eating the mashed potatoes and vegetables. Schools today in France have evolved to have vegetarian and vegan options, but at my time it was a big issue.

One inexpensive meat they would often serve was beef tongue. They'd serve it sliced with brown sauce and potatoes. I actually loved it but I know the other kids didn't like it.

Quenelle was a very French dish they served once a week. Now it's one of my favorite dishes, but it's one of those things you only like when you

become an adult. It's heavy and weird looking, like white sausages made of bread and meat, swimming in béchamel sauce. Quenelle day was the day we'd steal the most bread.

Bread is such a big part of French culture. Living here in the States it's hard for me as there isn't the same bread culture. If we go out I often have to ask for the bread. If the server then forgets to bring it I go crazy. My American husband is like "Chill out!" but I can't eat and my food is getting cold because I can't start without the bread. It's like being served food without a fork—you *could* eat with your hands but you don't want to because that's gross. It's like that with me for bread.

THE LUNCH LADY
VIVIAN WRIGHT

School Lunch Helper | Brooklyn, New York, 1945

WHEN I WAS A KID, OVER SIXTY YEARS AGO IN BROOKLYN, WE HAD soup plus a peanut-butter-and-jelly sandwich or a cream cheese sandwich. That was it. The kids today have way more variety. We never had yogurt, or popcorn chicken, or dumplings.

Even though these kids get a lot more choices now they still eat what they eat. The new stuff they keep bringing out doesn't always go over as well. I see a lot of it in the garbage. Kids are prone to not eat vegetables for whatever reason—some do but most don't. The lunches have gotten healthier but the kids aren't going always going for the healthy. The most popular lunches are popcorn chicken, burgers and fries, chicken dumplings, and pizza.

This is my second career. I worked at Citibank for thirty-six years but retired after the World Trade Center came down. I was four blocks from the Trade Center so just about everybody lost their jobs when they had to relocate everything. I stayed home for five years, then got tired of staying at home and decided to take this job part time. I said I was only going to do it for five years—ten years later I'm still here.

This job is definitely a big change from my old one; the biggest thing to get used to is how kids today treat adults. When we went to school you could not say anything derogatory to an adult, but now these kids don't care. From eight to eighteen, they have no respect. And you can't say anything because if a kid complains, even if you didn't do anything wrong, you don't have a job.

It's not all of them, just a few, but some of the kids you just can't reach them. Some of them have serious problems, they come from shelters or have trouble at home; this is the public school system, you're dealing with all walks of life. In my personal opinion, they should put those kids in a problem group instead of mixing them in with everybody else. There are some kids who want to learn but by the time you quiet that one kid down the rest of the kids have started acting up.

Our cafeteria actually serves kids from three different schools that share the same school building. There's a small elementary school that includes kids with lots of special needs, a progressive K-5 charter school, and public middle school. I serve the special needs kids on one side of the lunchroom. I like working with them. They come through with an aide who helps them ask for the food. These kids are autistic and nonverbal but you can still educate them and work with them. The older kids from the middle school, who are fourteen, fifteen, sixteen—they're already where they going to be. When they get to a certain age, there's not much you can do; half their parents can't do anything with them.

This is the first year of the free lunch program in New York City and we definitely serve more kids now. Before, they had to pay and some parents couldn't afford it. Now more kids are able to eat. It's a good program.

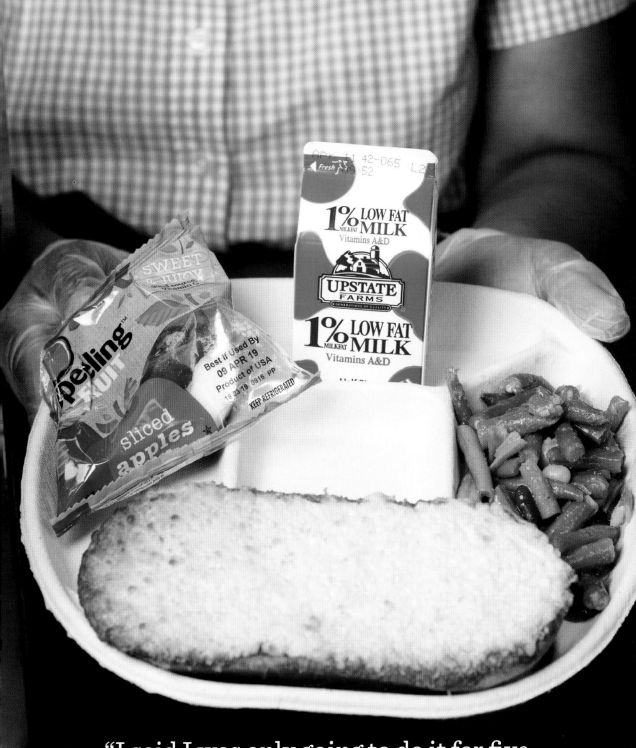

"I said I was only going to do it for five years—ten years later I'm still here."

SCIENCE TEACHER'S LESSON IN WASTE

MARTHA BERNABE

Prop Stylist and Set-Designer, Owner of Prop Haus
(a Props Rental Company) and Co-Owner of Ore Bar in Brooklyn, NY
Great Falls, Virginia, 1981

ONE DAY IN FOURTH GRADE MR. COLE, OUR SCIENCE TEACHER, TOOK the garbage out of the lunchroom garbage can. When we arrived to science class, which was right after lunch, he had a big tarp spread on the floor. He had us all sit in a circle on the edge of the tarp—the same area we'd sit to dissect a sand shark and do other science experiments. He dumped the whole bag of garbage onto the tarp and started sorting through it. He pointed out what could have been composted or recycled and what was perfectly good unfinished food. He even ate some of it! He took a bite of someone's sandwich, ate some of a whole apple that had been thrown out and ate a spoonful of yogurt—all to demonstrate how we'd wasted perfectly good food. He wanted us to change how we think about garbage. This made a big impression on me. He did this for every class that year; it was when Earth Day was really getting started. I always thought Mr. Cole was cool and a great teacher. I considered him a friend.

> "He pointed out what could have been composted or recycled and what was perfectly good unfinished food. He even ate some of it!"

MUSHROOM AND ONIONS
KATHERINNE ESCANDON

Student | Brooklyn, New York, 1997

ELEMENTARY SCHOOL LUNCH WAS PROBABLY THE BEST PUBLIC school food I got. It was all downhill from there. I went to PS 29, which was mostly occupied by rich Carroll Gardens kids. I was one of maybe twenty other children of color. At the time, it was "the best" in part because the students' families were rich and could afford to donate loads of money to essentially make it like a private school. Our school festivals had pony rides.

I loved the Uncrustables sandwiches which were pockets of bread filled with peanut butter and jelly. My favorite, though, was the holiday lunches they would give us around Thanksgiving with mashed potatoes, thinly sliced turkey, and the best gravy. Since I'm from a Hispanic household we never had this traditional meal at home.

I also had a strange phase where I loved sautéed mushrooms with onions. My mom would pack me just that with nothing else for a while. I'm very over it now. I remember being jealous of my best friend's goldfish crackers, which she would bring in a baggie every day and generously share with me. We were by no means struggling but my mom was a single mother and it was better for us to not waste money on brand-name snacks.

I commuted to Brooklyn from Staten Island for school. I definitely stood out; everyone was into Harry Potter and I had no idea what that was. I didn't have the same cultural background as them, and the other white children bullied me for it. I'm Ecuadorian. I made fast friends with a Puerto Rican girl, and we've been friends ever since, going on a decade now.

DAD'S APPLES

ROBIN GREENE

Photography Agent
Edmonds, Washington, 1991

MY MOM WAS GREAT AT MAKING LUNCH. SHE MADE A DELICIOUS homemade minestrone soup with hamburger meat, shells, canned stewed tomatoes, beef broth, and veggies. I also usually got a Granny Smith apple cut up (and slightly brown by lunch time).

I could always tell when my dad packed lunch by the way the apples were cut; he'd cut it in half just to one side of the core, then rotate and repeat and then cut those pieces smaller, leaving a cube core to toss out in the end. It was faster but looked strange. Now that's how I cut apples, too. Our school milk came in a pouch that you'd stab with a pokey straw; I never knew this was a regional thing.

"My mom was great
at making lunch."

INDIAN CARRIED LUNCH

JANAKIRAMAN SOMASUNDARAM

IT Software Engineer | Tamilnadu, India, 1981

GROWING UP IN MY HOMETOWN, WE ALL CARRIED LUNCH FROM HOME in colorful *koodai* plastic mesh bags. There was no option to buy lunch at school. I carried curd rice with pickles as a side almost every day. It would be packed in a stainless steel round container with two layers. I'd also usually have some vegetables, often just boiled or steamed with salt and raw shredded coconut. We ate with our hands. I live in the United States now but remember it all so clearly.

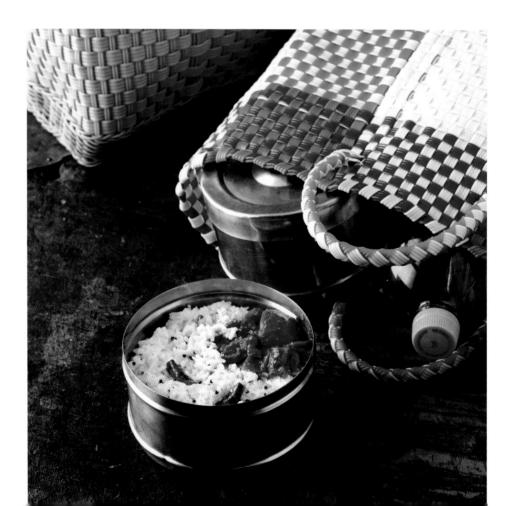

KAKA'S SUGAR SANDWICHES AND HOMEMADE CHIPS

CLARE HUSSAIN

Restaurateur | Dhaka, Bangladesh, 1978

MY SISTERS AND I WENT TO A SMALL CHRISTIAN MISSIONARY SCHOOL, which I loved. There was a lot of "Kumbaya" singing and stuff like that. My father was Muslim, and my mom converted to Islam when she eloped with my father but we were a nonreligious family. I'm not sure why they sent us to this school but there were a lot of missionaries and expats there.

We had an amazing Bengali cook who had learned a lot of English recipes and also cooked phenomenal Indian and Bengali food. We called him Kaka, which means "Uncle" in Bangla. He was very near and dear to us for many years.

Our lunch seemed very basic compared to his skills and capabilities. We would have sugar sandwiches, homemade potato chips, and segmented oranges (with every little membrane removed because we were so particular).

I remember not being terribly riveted by my lunch. I used to wish to have what the American expats got, a PBJ sandwich or canned deli meat from the commissariats. They would have had these cool foreign meats. We didn't have access to that because our parents didn't have international work contracts like they did.

My mom worked full time as a nurse. She would wake up first thing and have her thermos of coffee and a cigarette at the table and then leave for work. We weren't particularly affluent, but it was the norm back then to have a household staff. Our nanny would get us ready, Kaka would make our lunches, and our driver would take us to school.

Dad had minimal involvement in our lives before my mom died when I was eight and my twin sisters were four. After that he became a lot more involved. This was out of necessity but also because my mother's death was an awakening for him. We all became very close. After my mom died, my dad was my rock.

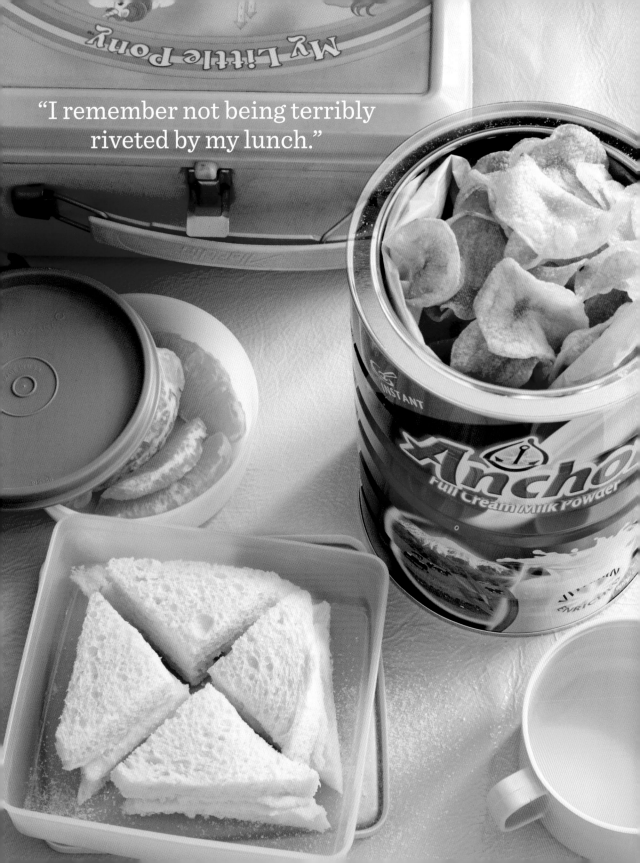

"I remember not being terribly riveted by my lunch."

GRANDPA SANDWICH
AMANDA PLUMB

Runs Chow Club Atlanta, a Monthly Underground Supper Club in Atlanta, Georgia
Rock Hill, South Carolina, 1977

THE WEEKLY SCHOOL LUNCH MENU WAS PRINTED IN THE TOWN NEWS-
paper. I would check it out and decide when I'd bring lunch and when I'd
bring money to buy lunch. I typically took lunch in a brown bag, but Taco
Salad Day was my favorite, so I'd buy lunch on those days.

My favorite lunch was when my grandpa visited from Tampa and made me
a "grandpa sandwich." It was salami, stinky provolone cheese, and French's
yellow mustard on Cuban bread. It must have smelled horrible to my class-
mates, but I didn't care.

LOVE-HATE RELATIONSHIP WITH FOOD

RABBI MANIS FRIEDMAN

Chabad Lubavitch Hassid, Rabbi, Author, Social Philosopher, and Public Speaker
Born in Prague, 1946, Came to Brooklyn, New York, 1950

————————

EATING IS SUCH A BIG PART OF OUR LIVES, BUT WE GET MIXED MESSAGES.
On the one hand, we're told not to be hung up on food—don't be such a glutton, don't be so picky, it's not nice, it's animalistic, it's degrading. On the other hand, food is a very powerful source of nurture. Not so much because of *what* you eat but because you're being fed. These two sides give us a love-hate relationship with food. A lot of people get confused by that.

There's no point in arguing that eating is beautiful, because it's not. What really is the redeeming function of food is its social value. If you want your child to grow up to be a decent human being, it starts with food. The way they eat and treat food is going to set the tone for many things in their future as adults. How you treat the people who eat with you? That's the whole story of Life right there.

When I was a teenager I asked my mother "What's for supper?" I only made the mistake of asking that once. The answer was "Food." Once we didn't have food and now we had food so what's your problem. She had eight kids to feed.

My school was an all-boys Yeshiva school in Bedford Stuyvesant. The school cook was an old Russian woman. She made it a point to pay personal attention. She would make something special. She had to serve about two hundred kids but when I came through she'd have me wait and she'd fry up an egg just for me. I'm not sure what she saw; maybe she noticed I wasn't eating the scrambled eggs. It was just so reassuring to be noticed, to be cared for. I don't remember the rest of the meal, it was unimportant—with just that egg she made lunch the best part of my day.

In the Hasidic community, before we eat we say the appropriate blessing for that food. You're essentially thanking God for that food and taking permission to eat. It elevates the act of eating to something a little more dignified.

When eating is a social activity it becomes a meaningful, character-molding, almost spiritual experience that's a lot better than just "gimme." Learning this will affect everything else in life. Take business, for example—making a couple of dollars is like eating. You can be gluttonous—I need this, I need this *from you*—and this way "you" becomes the enemy. Or instead you can see business as a good excuse to interact, to become interdependent. Marriage and intimacy are related to this idea as well. You see a kid eating like a glutton and you know his wife is in trouble (if you're greedy with your food. . .). If you are observant and intuitive, you can watch someone eat lunch and know everything about them.

"How you treat the people who eat with you? That's the whole story of Life right there."

SAD CAFETERIA

KIIA WILSON

Herbalist | Memphis, Tennessee, 1992

MY MOTHER HAD MUNCHAUSEN SYNDROME, SO SHE LOST CUSTODY OF ME when I was an infant. I was in foster care until my dad's grandmother took me in, and then after that my dad and my great-grandmother raised me. I have never met anyone from my mom's side of the family; they remain a mystery to me.

 I went to a few schools as a kid but the food was all the same. The cafeterias were loud and somehow cold even though we were in Tennessee. The paint was peeling, they weren't even trying. We had those rectangle pizzas with mystery meat or pale chicken tenders. Sometimes we'd get a fruit cup and overcooked string beans or corn. I liked it all fine when I had elementary-school taste buds but as I got older I realized how bad it was. I did still love the pizza, though.

 I used to be bullied and I used lunchtime to nap more than socialize. I was a very playful and curious child but also pretty sad because I didn't know my mom the way the other kids did. I'd find peace outdoors in the trees. I work as an herbalist and doula now and think some of my need to help heal people comes from those early experiences.

QUAIL EGGS WITH GUAVA SMOOTHIE

MARIANA VELASQUEZ

Food Stylist and Tastemaker
Bogota, Colombia, 1981

I WENT TO AN ALL-GIRLS CATHOLIC SCHOOL NINE THOUSAND FEET UP in the Andes. In elementary school we had lunch boxes; my mom and dad would pack mine each morning.

In my thermos I'd get a smoothie, guava and milk, or curuba and milk. It was delicious but would often leak all over the rest of my lunch. I loved hard-boiled eggs, but they smelled bad so my mom would pack me three hard-boiled quail eggs because they didn't smell. I'd peel them and eat with golf sauce (which was pink—just ketchup and mayo) and pita bread. I'd get a little dessert, which I loved. It was often Alpina dulce de leche or a slice of Colombian fresh cheese.

ENGLISH MOTHER, AMERICAN FATHER

MELINDA NELSON

Writer and Editor | Edina, Minnesota, 1962

I WAS BORN IN ENGLAND TO A BRITISH MOTHER AND AN AMERICAN father. I was seven when we moved to Minnesota, and my parents gave me the choice of Catholic school or public school. I made the decision based on lunch. I wanted to go to Wooddale—the public school—because they allowed you to bring your lunch. As a kid this was a very empowering idea.

In England, my parents had sent me to a convent school called Saint Maur's where we were served hot lunch in a Harry Potter-like dining room. One Friday, when I was six, they served fish in cream sauce. I told the nun, "If I eat that I'll be sick." They were very strict nuns so she told me to eat it. I put one bite in my mouth and I threw up all over the Harry Potter wooden table. As punishment they put me in a room by myself. I remember being so mystified as to why I was in trouble when I had *informed* them that I would be sick.

A year later, to go to America and be in charge of one's lunch decision felt extraordinary.

Having grown up in England I wasn't familiar with tuna. Tuna sandwiches were a uniquely American thing, and they smelled disgusting to me. I was used to English food. I had a fondness for thin-sliced Pepperidge Farm bread. Other kids had grape jelly but grape was not a flavor in England. In England, instead of grape jam, or juice, or gum—we had black currant. So I'd have crunchy Skippy peanut butter with black currant jam, which no one else had and was considered very eccentric. Now that I think about it, my lunch was a funny metaphor for growing up with an English mother and American father—the marriage of black currant jam and Skippy peanut butter.

The price of school milk at the time was two cents. Everyone who brought their lunch Scotch-taped (or Sellotaped, as my English mom would say) two

pennies to the inside top edge of their brown paper bags. At lunch time, we would unstick the pennies to buy the red and white container of milk.

The father of my dear friend Anne McBurney was the VP of Marketing at Pillsbury. In the seventies, Pillsbury introduced Space Food Sticks. This was the era of astronauts landing on the moon; popular culture was all about space. General Mills was making Tang, but Pillsbury was making Space Food Sticks. They looked like beef jerky but they were chocolate and peanut butter and packaged in silver. Anne's cabinets were stocked with products before they landed in grocery stores, and I would get them from her. My lunch became a weird hybrid of England and next-generation America.

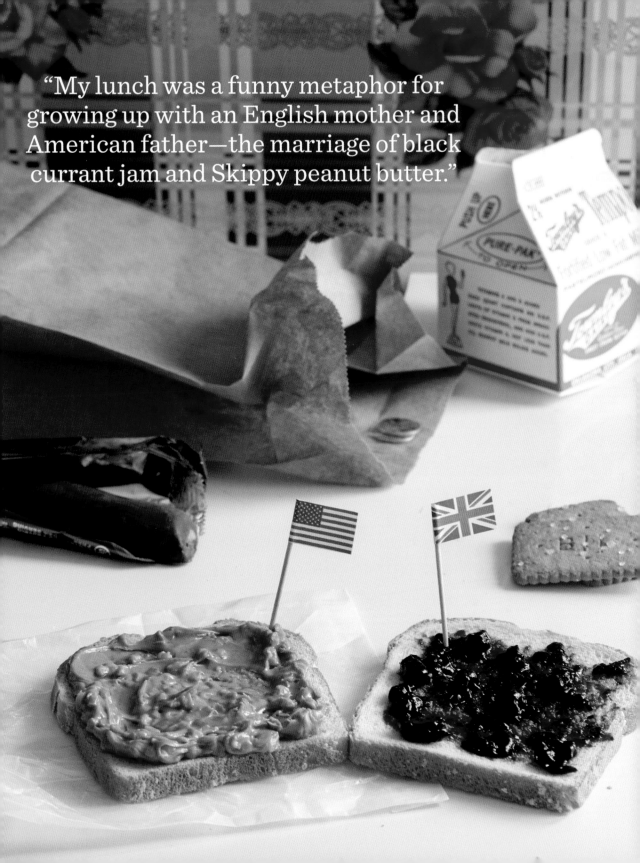

"My lunch was a funny metaphor for growing up with an English mother and American father—the marriage of black currant jam and Skippy peanut butter."

JAPANESE BALONEY
AYA OGAWA

Playwright, Director, Translator
Higashikurume, Tokyo, Japan, 1974

———

I WAS BORN IN TOKYO, BUT MY FAMILY MOVED TO TEXAS AND THEN Georgia for a few years before we returned to Japan for my grade school.

In the United States, I acquired a taste for baloney. Back in Japan, my earliest school lunches were baloney on white bread with mayo with crusts cut off. Our name, Ogawa, is written with two different kanji 小丿川 and means Small River. My mom would cut my baloney sandwiches into little kanji rectangles that would spell this out.

Our school had a huge storage closet full of instant noodles in case of national emergency. Tragedy never struck, but the packages had expiration dates, so once a year they would cook it up for the students. We never knew in advance when yakisoba day would be but we all really looked forward to it.

———

"Our school had a huge storage closet full of instant noodles in case of national emergency."

———

FROZEN WONDER BREAD LOAF

VANILLA MARCIA-RODRIGUEZ

High School Science Teacher | San Antonio, Texas, 1976

MY MOM WOULD MAKE AN ENTIRE LOAF OF BREAD OF HAM SAND-
wiches and freeze them. She would place them in my lunch bag in the morn-
ing and they were supposed to defrost by the time I got to lunch. It never
really happened but I still loved them.

I lived in Italy for some of my elementary school years. My dad was in the
military so I went to a DOD (Department of Defense) school. One time, the
teacher took us to the seashore and picked up a sea urchin from a tidal pool.
He cracked it open with a fork and gave us each a spoonful raw. It was the
best lunch ever!

NORWEGIAN BREAD, EGGS, AND A NOTE

PAUL LOWE

Editor-in-Chief of *Sweet Paul* Magazine,
Creative Director, Food Stylist, Ceramicist
Nordstrand (Suburb of Oslo), Norway, 1966

———————

IN NORWAY WHEN I GREW UP, YOU WOULD BRING YOUR OWN FOOD for school lunch. My mother or grandmother would make my lunch, and it was more or less the same thing every day. I'd get three slices of buttered dark rye bread and two boiled eggs, peeled and cut in half. I loved salt and pepper so I also had little silver salt-and-pepper shakers they would pack in my metal box. They also always packed a little cheerful note or drawing.

The box was my grandfather's so it was really old. The other kids made fun of me for it but I didn't care. I remember my sister would have four Wasa crackers with butter and brown goat cheese every day. At school they would give you milk and a piece of fruit. There was a separate table for the kids who couldn't drink milk.

Jeg elsker deg!
Gjøre det bra i dag ☺

"The box was my
grandfather's so it
was really old."

MANGU AND DOODLES
ELIANA PEREZ

Fine Artist | Santiago, Dominican Republic, 1992

I USED TO EAT *MANGU* A LOT, MY MOM WOULD PACK IT IN MY DORA the Explorer lunch box. Mangu is a Dominican dish that consists of boiled and smashed plantains. On top of that would be stir-fried onions and fried salami. It was the best! I also had a juice box or chocolate milk.

I used to always keep a drawing notebook with me and every time I ate lunch, I used to doodle a lot. Even all of my history or math books got covered with my drawings. I got in trouble but I don't regret it.

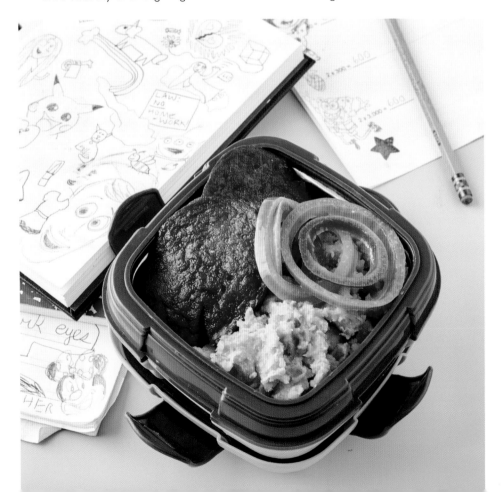

HOME-SCHOOLED LUNCH

ELI GRUBBS

College Student | Pine City, Minnesota, 1998

I WAS HOME-SCHOOLED PRETTY MUCH ALL MY CHILDHOOD. WHEN I was younger my mom was around every day and she made lunch. When I was around eleven or twelve, I would make lunch for my two little sisters and myself. Once my sisters were old enough to make their own lunches we'd all do our own thing, but my sister Grace and I had to help our youngest sister, who has special needs.

We went to school year-round and our lunches were pretty seasonal. In the winter, we pretty much always had some sort of soup around. We had multiple Crock-Pots with soup or chili going, which was usually lunch. We'd eat leftovers two or three meals a day, which made things a lot easier.

When we moved out of the soup season we'd make a ton of big meals that would last us for days. Like a big rice dish we could all have for three days. We call them bowls. We'd take the rice and add salad or veggies. We'd use the rice to make burritos, wraps, tacos; or we'd just add it to soup. We also had a lot, *a lot*, of fruit. We'd have two to three apples each or an orange or smoothie for breakfast or snacks. Pasta salads were also pretty big. I was always a big fan of Coke so I'd have that with lunch. Our grandparents came up every weekend and brought a couple packs to last the week.

In general it was very healthy. I'm not as healthy now. Little Debbies have taken over a little bit.

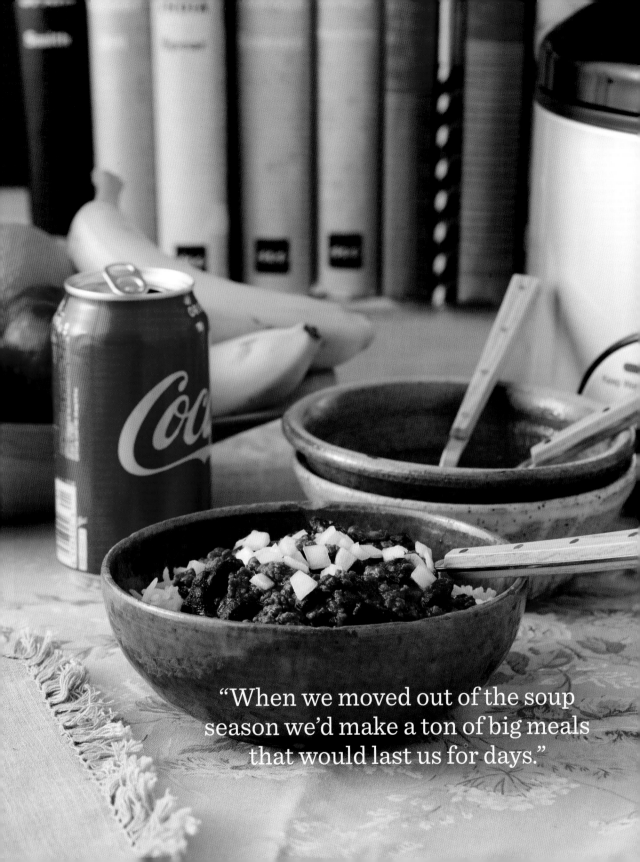

"When we moved out of the soup season we'd make a ton of big meals that would last us for days."

BREAD AND MEAT IN KAZAKHSTAN

ZHANNA KURMANOVA

Photographer | Almaty, Kazakhstan, 1990

WE ATE TOGETHER IN THE SCHOOL CAFETERIA. IT WAS MOSTLY QUICK-
grab foods they made there, not a whole meal. I usually bought a Russian
dish called *Sosiska v teste* (Sausage-in-a-Dough). They had *pirozhkis*, too,
but they cost more so I would always get the cheaper one so I could keep
the change in my pocket. I would tell myself it would be enough for me so I
could save my money, but at the end of the day it wasn't so I'd run back and
get another.

Apples that didn't sell that season would be collected and dried, then
boiled in water and cooled down to make this cheap, homemade drink called
Kompot. They had a huge aluminum bowl and this very large lady with a
white hat would pour you some in a glass. It had a pink-purplish color.

You could also buy baked things or chocolate. Very rarely, if it was an
extra special day and my dad gave me more money, I'd get a Bounty bar.
It was the one thing that was super expensive because it was from abroad.
Everyone who bought that would walk around with that bar and eat it really
slowly so the whole school could see.

There were no vegetables. It was all dough and meat. Looking back there
was no nutritional information and no one really cared. Adults and kids—as
long as there was something to eat—everyone was fine.

"Everyone who bought that would walk around with that bar and eat it really slowly so the whole school could see."

MACROBIOTIC TALL POPPY

RIKKI MARKSON

Writer and Psychologist | Sydney, Australia, 1988

EVERYONE TEASED ME FOR THE BEING THE VEGAN KID. TWENTY YEARS ago it was *very* strange.

When I was eight, my dad was diagnosed with Merkel cell melanoma. At the time, no one in Australia had ever survived that cancer diagnosis. He was given a 50 percent chance of surviving six months, then 50 percent again and again after that. My mom wasn't going to take this diagnosis lying down; she is a real problem solver. She did a ton of research and decided to turn us all macrobiotic. We'd always been vegetarian, but this was a whole other level. We stayed macrobiotic for two years, then went to being vegan. I'm still vegan today.

In a macrobiotic diet, 50 percent of what you eat is whole grains, and organic and seasonal vegetables make up most of the rest. There are a lot of fermented foods but nothing acidic and no nightshade vegetables like eggplant and tomatoes. It's really crazily strict. However, when it was time for my dad's surgery a few weeks after being on this regimented diet, the tumor had shrunk. This was unheard of, the doctors didn't understand it. He still had to undergo chemotherapy and everything but he's still alive today and I'm almost thirty-one.

My school lunches were very strange to the other kids. Everyone teased me for my strange food. During our macrobiotic phase, I got adzuki bean and pumpkin stew. It tasted cold, sweet, and spicy—with ginger and salty tamari. I'd also get a mango or peach. The fruit was often overripe and squished in my hands.

One day I left my lunch in the playground by mistake, and a teacher picked it up. She took it to the principals, wondering how they would ever find out who it belonged to since it was an unlabeled brown paper bag and my school had over a thousand students. But when she opened it up, she took one look inside the bag and said, "It's Rikki Markson's lunch." No one else had a lunch like mine. The other kids had a lot of Vegemite and margarine on white

"No one else had a lunch like mine. My fermented seaweed really stood out."

bread. They'd have little packages of chips and Australian treats like Pizza Shapes and Twisties. My fermented seaweed really stood out.

In Australia we have something called tall poppy syndrome, where basically standing out and being extroverted is not celebrated like it is in America. My weird lunches combined with my extroverted tendencies got me bullied a bit. I loved everything my mom cooked, though. By the time I was in high school everyone wanted my lunch.

MEMORIES BLOCKED BY EARLY TRAUMA

SAH D'SIMONE

Author, Transformational Coach, Meditation Teacher
Londrina (Parana), Brazil, 1986

WHEN I TRY TO REMEMBER MY SCHOOL LUNCH I REALIZE THAT I HAVE blocked it out. I honestly can't remember anything about the food I ate, it's that closed off.

Many of my earliest memories aren't so pleasant. I realized that I was gay at a really young age and a lot of silencing happened growing up because of my queerness. As a young kid I was already living multiple lives. I'd be somebody at school, somebody else at after-school, and somebody else at night. This is very common in the gay community, this sense of having multiple or split personalities and performing to stay in a safe place.

One of the first memories I have is of crying in the bathroom. I had gone to judo class because my dad wanted me to do martial arts but the boys were shaming me because of how I moved my arms and talked so I ran home and cried.

As a kid, I wanted to wear makeup and wear my hair different and dance and sing. I wanted someone to say, "Hey, do you like girls or do you like boys?" and have whichever answer be OK and be supported. The unconscious silencing that I faced runs so deep. I smoked crack when I was fourteen years old, and looking back it was a desperate plea—I was saying, "See me, I'm here, I'm worthy."

I had so much rage inside of me because of having to be silent. I was sent to the principal's office often. I didn't have an opportunity to express myself fully so I had all this anger that had to come out. I was bullied, I was the bully—there were all these dynamics at school that brought a lot of pain for me.

My parents weren't emotionally agile and intuitive to understand that I was different so they would buy me a lot of stuff. I remember being showered with things. I don't remember the food I ate at lunch but I do remember having a pencil case with a lot of different pens. There was a pen that my aunt brought back

from America, so it was a big deal in Brazil. It was green and vibrated and was really big and weird looking and people loved that. I would take it out and put it on top of my pencil case. I had another pencil case that was a mini basketball court. It was a metal case and you'd open it up and a little hoop would come up.

There was a lot of love in my house, but there was not a lot of openness to discuss something that was different. My dad has only started to talk about my queerness (to my mom, not to me directly) recently, and my mom has only asked me about my dating life in literally the last two months. My dad's father was unavailable emotionally and my dad has unintentionally relived that with me. I'm now trying to break free of these things and make a change.

I work with a lot of parents, and I always tell them that showing physical affection is wonderful, but really being curious about the child's personal identity is so important in helping them develop for themselves.

I've been redesigning my relationship with my childhood memories as a lot of it I've unconsciously blocked out. Within my own community—the queer brown bodies—there's so much trauma. I teach people that none of your past trauma has to define your present moment. My early trauma has become the fuel to my mission in life, to help people reconnect with their hearts.

AN EXTRA LUNCH FOR SOMEONE IN NEED

FELICIA JOHNSON

Software Tester | New York, New York, 1985

I KIND OF BOUNCED AROUND THE BOROUGHS BUT I WAS BORN IN THE Bronx and spent most of my life there. We only lived with my father until second grade. After that, my mom separated from him and we moved out.

During the period I lived with my father, he would pack my lunch for school. I remember watching him in the kitchen. I'd be standing next to him, because he would have me help. We didn't have a lot of money, so lunch was simple—a peanut butter and jelly sandwich on wheat bread plus usually a banana and water or juice. My father was very health-conscious so he was adamant about the wheat bread. We never had regular white bread in the house.

I remember the first time he finished making my lunch and reached for more bread to make another sandwich. I asked him why, and he told me, "Just in case somebody doesn't have a sandwich or someone gets hungry. You can give them the other one." He made me two identical brown bag lunches. At that time as a kid, it didn't make the same impression as when you think about it as an adult. I remember thinking "Oh, great, I have to carry extra stuff now."

That day, when I got to school, my teachers said we were going on a trip. If you didn't have a lunch you had to stay behind. One classmate I really didn't know, he didn't have lunch and was told he couldn't go on the trip. I told the teacher that I had two and he could have one. I remember—vividly—the look on his face, the look of happiness. It sat with me. I still feel how satisfied I felt as a kid, realizing I had made this boy happy. At lunchtime I remember sitting and watching him open up the same lunch as me, so curious to see if he would like it.

Afterwards, I was so excited to tell my dad someone had needed my extra lunch. He just said, "Good. You know you're supposed to help. If you have something that someone else doesn't have, you give it to them."

After we moved out, my dad was still in my life but he wasn't packing me lunches anymore. My mom had four of us. She wasn't into packing, and the finances were tighter, so I started getting the school lunch. I didn't mind the change of food but I missed the bonding experience of making lunch with my father in the morning. My father was always very active and outgoing and optimistic. It was always nice to spend that morning time with him. I also missed having that extra lunch to give away. I liked helping people but it was slightly selfish because it always made me feel good. If I had a spare banana, I'd still try to give it to someone. That was impressed in my head: Give something to somebody.

That has traveled with me as an adult. My father really modeled this idea of sharing with those in need. If we had leftovers, he would wrap it up and give it to someone on the street. And now, that's exactly what I do as an adult. My dad is eighty-two now and he's still always giving food away.

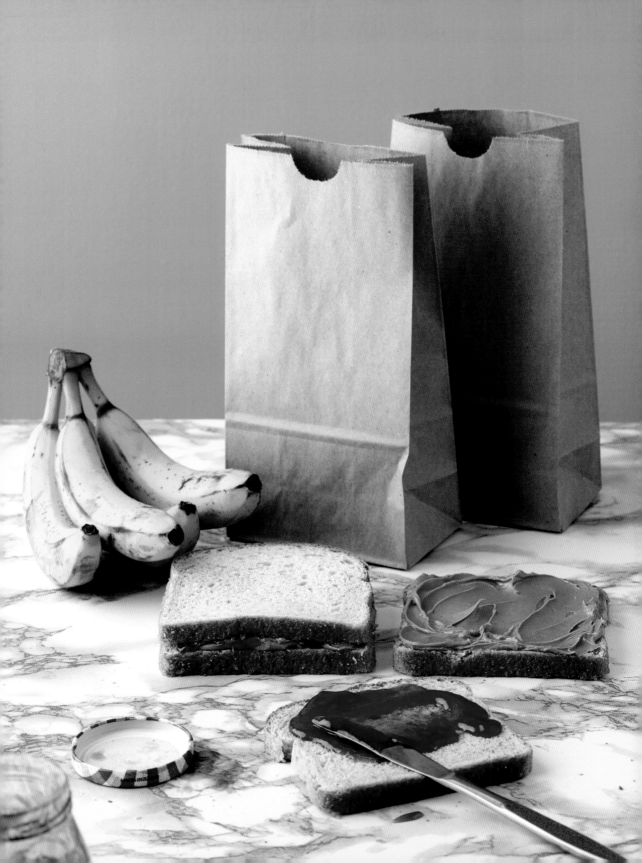

THE HORRIBLE FART DAY

MELISSA CLARK

Food Writer, Cookbook Author, Food Columnist for the *New York Times*
Brooklyn, New York, 1968

MY MOTHER WOULD TAKE THESE LITTLE CANS OF APPLE JUICE AND put them in the freezer. When she'd make my lunch she'd add one to defrost in my lunch bag. We didn't have those fancy insulated lunch cubes or cute ice packs they make today, so this was my mother's hack to keep my lunch cold. Her system was really good, and the juice was still a bit frozen at lunchtime so you'd even get a bit of a slushy to drink.

Every day I'd have egg salad on white bread. I *loved* egg salad. The little freezing can of apple juice kept it cold, which was great, because you really need to keep eggs cold. This I learned the one time she ran out of apple juice cans. Her system was so clever . . . until the day it didn't work.

It was June, in a Brooklyn public school classroom with no air conditioning. As I sat in school unaware, my lunch got hotter and hotter and hotter. And what happens when you unwrap hot egg salad in a June lunchroom? It smells *exactly* like farts. As I unwrapped it, everyone was staring at me—holding noses and complaining as I tried to meekly protest it was egg salad! Everybody made fun of me for *weeks* after that horrible fart day. Thank God it was June and almost the end of the school year.

I couldn't eat egg salad for years after that. I got over it, of course. Now I'm fully back to egg salad. I also don't care, to be honest, if everyone thinks I smell like farts. I'm a grown-up. I can handle it.

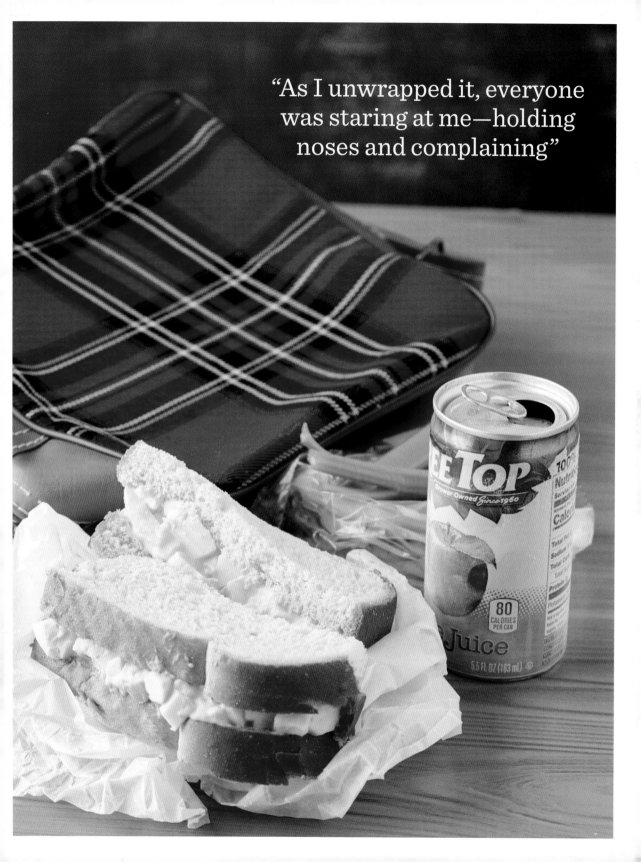

"As I unwrapped it, everyone was staring at me—holding noses and complaining"

Acknowledgments

I FIRST NEED TO THANK MY FANTASTICALLY SUPPORTIVE HUSBAND, Michael Lee, who has been a champion of my photography for this book and at every stage of my career. Michael has been listening to me talk about school lunches for three years and his belief in this project from the start—before a book deal or end goal was in sight—was what made it all possible. Thank you, Michael.

I'd like to thank my parents, for packing me endless lunches, and for always encouraging me to dream big but also work hard to do a job right—two qualities that have served me well as an artist. My daughters, Georgia and Annie, deserve credit for helping to plant the seed for this book. Having to pack their lunches sparked my curiosity about traditions in different times and places. They've also been my biggest cheerleaders, and there's nothing like the earnest support of a kid who believes in you to make you do your best work.

I couldn't have done this book as beautifully or elegantly without the amazing collaboration with stylists Christopher Barsch and Martha Bernabe. We started shooting these lunch stories as personal work, donating time and money to get them done. Having them as partners to share in the creative process made each food shoot a dream.

I have to thank Rica Allannic, my literary agent, who was the first "outsider" who read my concept and chose to believe in it. Her support throughout the process has been above and beyond. I'd also like to thank Ashley Klinger and Robin Greene, my commercial agents. Ashley signed me when I was green and has been my artistic advocate for almost a decade, allowing my work to grow and evolve along the way. Robin showed her support for this book and me by agreeing to be one of its subjects, teaching me about milk in a pouch in the process!

I'd also like to thank Kristen Green Wiewora and the entire team at Running Press. Thank you, Kristen, for seeing the potential in my proposal and saying yes to this book. Thank you for also fielding all of my first-time author questions and editing with such care. Your honest feedback and belief in the book has meant the world to me. Thank you to Amanda Richmond and the

rest of the design team for your beautiful work and your patience with my constant tweaks. And thank you to Cisca Schreefel, Martha Whitt, and the rest of the copyediting team for your dedicated attention to detail.

A huge thank you to Soraya Victory, for being my first reader, initial editor, and sounding board. Big thanks also to Daphne Uviller, Kate Cortesi, and Biz Jones for rolling up their sleeves and helping me run the Union Square Portrait Pop-Up booth, which collected eighty strangers' lunch stories; twelve of which I picked to include here.

I couldn't have done this book without the many people who helped me make connections to interesting subjects and stories. So many friends lent their support, but I'd especially like to call out: Sam Anthony, Kelsey Banfield, Elisha Cooper, Diana Cooper, Karim Dakkon, Kristin Donnelly, Jenny Gill, Ben Hayes, Fai Ho, Bea Hsu, Anthony Jackson, Yoni Katz and Jewish Brooklyn NYC, Alicia Kort, Jordan Kraft, David Larabell, Meira McFarquhar, Ellen Moncure Wong, Arthur Nazaryan, Melinda Nelson, Amber Parmentier, Claudine Pepin, Kelly Ramirez, Nina Shamloo, Babs Shelton, Jennifer Swartley, Frieda Vizel, and Micaela Walker. Additional thanks to Prairieland Dairy, the Pavek Museum, KARE 11, Prop Haus, Marcell's Italian Ristorante, George Foreman IV, Deramus Phiffany, and Jessica Drobka for "borrowing" many school milks.

I also have to thank the celebrities and influencers who took a risk on me, and said yes to being included in this book. Many of you (Padma Lakshmi, Jacques Pepin, Katie Lee, Laura Vitale, and Joy Bauer), said yes even before I had a publisher. Others (Gail Simmons, Daphne Oz, George Foreman, Marcus Samuelsson, Melissa Clark, Sam Kass, Chinae Alexander, Rabbi Friedman) said yes as the project grew and graciously carved time in your busy schedules for interviews and portraits.

Lastly, I must thank all of the subjects of this book who trusted me with their childhood memories. The early stories I collected were from family: my parents (Bill and Paula Schaeffer), my father-in-law (Hoasung Lee), and my sister-in-law (Joby Abragan). Old friends (Skid Moffet, Anna Ammari, Micaela

Walker, Clare Hussain, Beth Bennett, Aya Ogawa), neighbors (Josephine and Ariana Mangual, my corner bodega owner, Sammy Abed), and photo industry collaborators (Martha Bernabe, Mariana Velasquez, Paul Lowe, Jake Hakanson, Robin Greene) came next.

When my immediate contacts were wearing thin, I mined connections of my connections to get to my college roommate's aunt (Fereshteh Shokati), parents of my close friends (Rena Uviller and Jane Hsu), and people in my small hometown (Annegrete Barnum).

For the past three years I've asked pretty much everyone I've met, "What did you have for lunch when you were a kid?" No one was safe! Living in New York City made it easy to reach a wide variety of people with very diverse backgrounds. I turned into the kind of person who chatted regularly with Uber and Lyft drivers about their childhoods. The stories included in this book were the ones I found most compelling, but there were countless others I could have photographed as well.

School Lunch was a grassroots campaign and how I got to each subject is a story in itself. Thank you friends, family, friends of friends, and a wide community of people who made this all possible. Together, you made me feel a little better about humanity. *School Lunch* inspired me to go outside my comfort zone and talk to strangers. I'm so glad I did.

Glossary: Who and Where

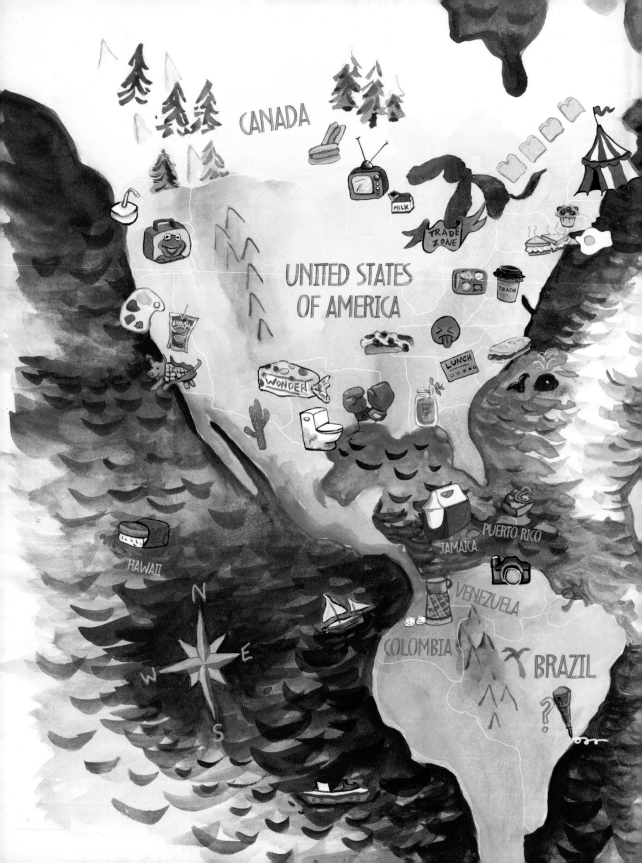

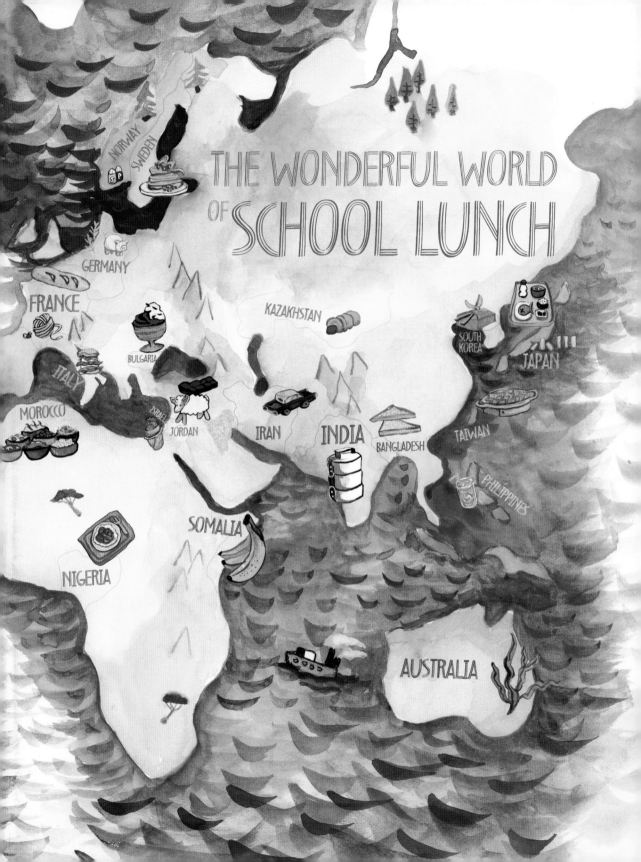

THE WONDERFUL WORLD OF SCHOOL LUNCH

NORWAY
SWEDEN
GERMANY
FRANCE
ITALY
MOROCCO
BULGARIA
ISRAEL
JORDAN
KAZAKHSTAN
IRAN
INDIA
BANGLADESH
SOUTH KOREA
JAPAN
TAIWAN
PHILIPPINES
SOMALIA
NIGERIA
AUSTRALIA

ASIA AND MIDDLE EAST

AUSTRALIA

CANADA

CARIBBEAN

EUROPE

SOUTH AMERICA